Comickers Art

Tools and Techniques for Drawing Amazing Manga

Comickers Magazine

comicbook

Tools and Techniques for Drawing Amazing Amazing Manga

Art

Comickers

Tools and Techniques for Drawing Amazing Manga

Art

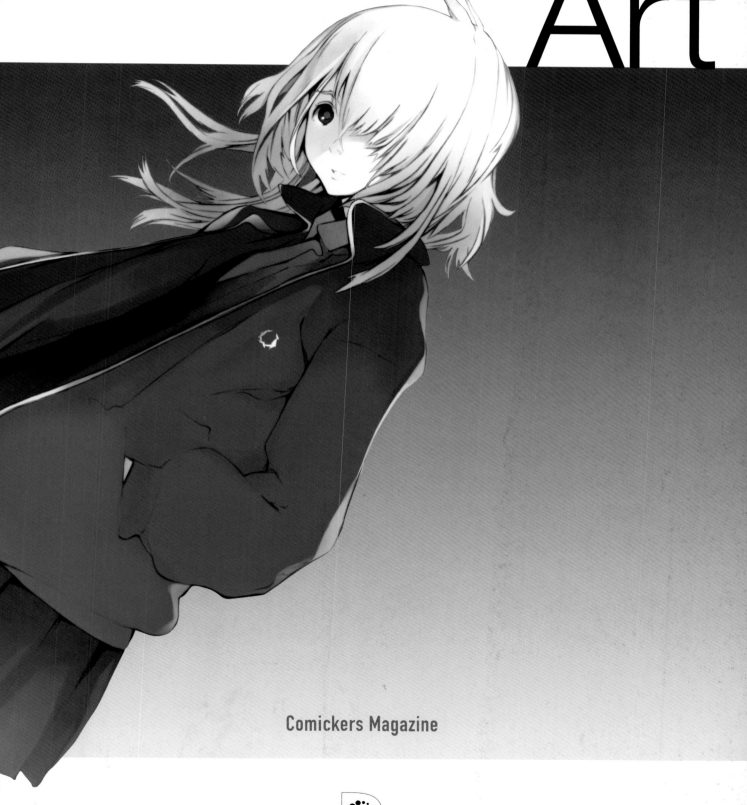

Comickers Magazine

COLLINS | DESIGN

An Imprint of HarperCollinsPublishers

Comickers
Tools and Techniques for Drawing Amazing Manga
Art

This book was first published in 2007 in Japan by:
Bijutsu Shuppan Publishing Co., Ltd. under the titles of
Comickers Art Volume 1 and Gekiman 7

First published in 2008 by:
Collins Design
An Imprint of HarperCollins*Publishers*
10 East 53rd Street
New York, NY 10022
Tel: (212) 207-7000
Fax: (212) 207-7654
collinsdesign@harpercollins.com
www.harpercollins.com
through the rights and production arrangement of
Rico Komanoya, ricorico, Tokyo, Japan

Distributed throughout the world by:
HarperCollins*Publishers*
10 East 53rd Street
New York, NY 10022
Fax: (212) 207-7654

English translation: Seishi Maruyama
English copy-editing: Alma Reyes-Umemoto
Book Design and Art Direction: Atsushi Takeda (Souvenir Design)
Typesetting: Yuko Ikuta (Far, Inc.)
Editorial Assistant: Aki Ueda (ricorico)
Picture Research: Yuri Okamoto
Chief editor and production: Rico Komanoya (ricorico)

Library of Congress Control Number: 2007938855

ISBN: 978-0-06-144153-0

Printed in China by Everbest Printing Co., Ltd.

First Printing, 2008

Contents

1
Artists and Traditional Tools

Selecting Drawing M

Have you experienced a moment when you didn't know what drawing tools to use for color illustrations? Do you use inappropriate tools just because you paid a lot for them and don't want to throw them away? This section will help you learn about the features of various tools and materials needed for illustration drawing. Then, you'll be able to choose what suits your style.

Criteria for Materials and Tools Selection

Water Resistance

Water-resistant materials produce interesting effects when water is added. Some types of pigments become opaque when they dry. You can also utilize such materials for outlines, and substitute them for acrylic or opaque paint.

Examples of water-resistant materials: acrylic paint, Dr. Ph. Martin's pigment, Holbein's colored Drawing Ink

Transparency

The effect of your drawing varies according to certain conditions, such as whether you can see the top color through the base color or not. An opaque color can become almost transparent by adding a lot of water. There are also colors that turn opaque when they dry, so choose the paints that are best suited to your drawing.

Examples of transparent materials: transparent watercolor, water-soluble colored ink

Using a Computer

Computer technology has become one of the major choices for drawing. Many professional artists use computer graphics, and many young people no longer regard it as a special tool for showing off their artistic abilities. The software market has evolved tremendously, producing many products with wonderful functions. Computers and software are expensive, so you should understand what they entail before investing in them.

Examples of software products for computer graphics:
Adobe Photoshop, Painter

Reasonable Prices

Preparing an adequate number of different colors—about 12—can cost a lot. If you are not particularly choosy about the manufacturer, you can buy some materials (transparent watercolors, opaque watercolors, and colored pencils) at reasonable prices. Many professionals use these types of materials due to the high cost of computer graphics.

Examples of materials at reasonable prices: colored pencils, watercolors

Color Sharpness

Colored inks and markers produce the sharpest colors. Primary colors create dazzling and vivid images on the paper, and you can carefully adjust their sharpness by adding water or using other methods. Mixed colors, however, tend to appear dirty.

Examples of materials that produce sharp colors:
colored inks, markers

Thick Coats

Unlike normal painting methods, thick coats of paint can create rough layers, as in oil painting, if applied with a painting knife. You can also produce an interesting surface by combining the paint with another medium. You will then have infinite opportunities to come up with new effects by adjusting the amount of water.

Examples of materials that produce thick coats: acrylic paint

Q&A Choosing Painting Materials

Q: How many colors should I prepare for drawing?

A: You don't have to invest a fortune in buying many colors. The cost depends on the type of material, but you could spend a huge amount of money for certain types of paint if you buy a lot. A typical starter's kit of 12 colors should be enough, but it could be fewer for a simple painting. It is sufficient to start with three or four of your favorite colors—ones that you use frequently. Later, if you need more colors, you can add some into your color collection.

Q: Is it better to buy more expensive paints?

A: It is true that imported high-grade paint is easy to draw with and has sharp colors. Many famous artists choose such materials, so many people tend to use them as well. However, a material cannot be good just because it is expensive or bad because it is cheap. You have to use it and see if it is easy to draw with in order to decide whether the material is good or not. It is never too late to start using high-grade painting materials, once you have developed your own techniques and painting style.

Q: What tools and materials should I have?

A: The basic and minimum painting tools and materials, other than computer graphics, are paper, paints, brushes, and water. In addition, you will need a palette and a bucket of water. You may buy other types of brushes, tissue paper, or cloth to wipe brushes, boards to stick paper on, and other articles that you like.

Q: How should I take care of my painting tools?

A: Careful treatment of your painting tools enables you to keep them for a long time. Paint or ink on the palette or in the bucket should be washed away thoroughly and dried thoroughly. Brushes should be rinsed well and treated carefully in order to maintain their flexibility. Wipe off the brushes well, and apply some conditioner to the bristles to preserve them. It is best to keep brushes inside their cases and to prevent the tips from becoming bent or twisted.

Q: What kind of tools and materials do professionals use?

A: Some professionals use high-grade tools and materials, and others use basic paints that are found even in elementary schools. It is not the grades of materials that determine the quality of paintings. It is the ability to choose appropriate materials that match the characteristics of your work. The tools and materials introduced in this book are used by many professionals, so go ahead and feel free to use this list as your reference.

Key Painting Tools and Materials

There are so many painting materials aside from paint—markers, inks, computer graphics, and many other tools—that you may have trouble deciding which one to use. The following descriptions of key painting tools and materials, with the characteristics of each, may help you choose what's best for the effect you want to produce.

Colored Ink

Colored ink is characterized by sharpness, beauty of color, and ease of flow. It mixes well with water, so it is best for techniques that need water, such as blotting and gradation. However, it discolors very easily, so store it away from light if you want to keep it for a long time.

Photo: Dr. Ph. Martin's Water Color Ink,
Radiant (BonnyColArt)

Colored Pencil

Everyone is accustomed to using colored pencil. It can be bought anywhere and is not expensive. There are many methods for applying it to produce a variety of expressions. It comes in oil-based and aqueous colors to help you color your painting in various ways.

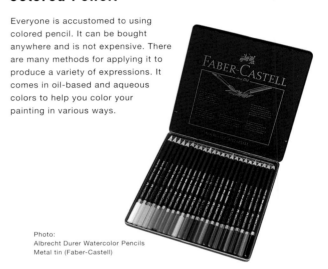

Photo:
Albrecht Durer Watercolor Pencils
Metal tin (Faber-Castell)

Acrylic Paint

This type of paint is made from acrylic resin. It has sharp colors and is waterproof when it dries. It is also opaque, which means it covers the underlying color. It has a wide range of functions; you can overlay the colors as you do with oil paint or add a lot of water for watercolor use.

Photo: Golden Acrylics (Turner Colour Works)

Computer Graphics

More and more professional artists are using computer graphics to create color illustrations. Computer graphics do not leave you with a mess in your workspace and can color your works more easily. Immense progress in software development has realized better digital painting than analog painting. However, you need to be ready to spend a fair amount to purchase the computer and software.

Photo: Adobe Photoshop CS3 (Adobe Systems)

Oil Paint

Oil paint is dissolved in an oil-based solvent, such as painting oil. It takes time to dry, but this becomes an advantage for mixing colors or expressing delicate features. This medium enables you to overlay colors or to give the effect of transparency by adding a lot of oil.

Photo: Holbein Artists' Colors

Opaque Watercolor

Opaque watercolor paints are commonly used in elementary schools. They block the color underneath so you can overlay them when they dry, but they can also be used as transparent watercolors by adding a lot of water. Poster paint is a similar type of opaque watercolor. Its bright colors and availability make it attractive.

Photo: Holbein Artists' Gouache
(Holbein Works)

Marker

Markers do not make your workspace messy and are easy to paint with. They also have sharp colors, which are oil based and alcohol based. The ink in one popular marker can be refilled and the nib be changed, so it can be used longer. However, the cost for many colors may be high.

Photo: Copic Sketch (Too Corp.)

Transparent Watercolor

This type of watercolor also produces bright colors and is readily available. It shows through the underlying color, so it is handy for blotting and gradation techniques. Sometimes, its texture is inconsistent, but it mixes well with other colors and can produce deep colors. It enables you to produce many effects with just a few colors.

Photo: Holbein Artists' Water Color (Holbein Works)

Other Paint Media

There are many other excellent paint media available at stores. A new tool may help expand your artistic techniques.

Waterproof Colored Ink

Waterproof colored ink spreads well, like colored ink, and it becomes waterproof when it dries, which can create an interesting effect. It has sharp colors and can produce beautiful blotting and gradation effects by mixing it with water. Be careful when using it, because it dries quickly.

Photo: Holbein Drawing Ink
(Holbein Works)

Pigment

The materials used for Japanese-style painting may not seem easy to find, but solid pigments, which are dissolved in water, are the most popular paint medium for Japanese-style painting. They have distinctive sober colors that are different from Western colors.

Photo: Kissho Gansai Japanese Watercolors
(Kissho Co. Ltd.)

Aqueous Oil Paint

The chief characteristic of aqueous oil paint is that it can be diluted with water instead of oily solvents. It can also be mixed with other watercolor or oil paint to create original colors for a variety of purposes. It dries more quickly than regular oil paint. Also, the brushes can be washed with water.

DUO Aqua Oil Color
(Holbein Works)
http://www.holbein-works.co.jp/english/index.html

Mastering the Use of Water

Water is indispensable when drawing with traditional art media. If you master how to use water properly, you will be able to acquire an expanded range of results.

Understanding the Characteristics of Paint

To master how to use water properly in painting, let's begin with understanding the characteristics of paint. Some of the keywords to learn are: opaque, transparency, water-soluble, water-resistance, and more. Check what characteristics your chosen paint may have when you refer to the section on paint media.

If you choose a highly transparent, water-soluble medium, you may use a lot of water and start painting with light colors, then overlay more colors. It is also possible to achieve a blotting or gradation effect by applying water in advance.

With acrylic paint, it is possible to vary the texture by adjusting the amount of water. By mastering how to use water well, you will have a good command of drawing techniques, such as producing a strong or light touch, lively or soft drawing, beautiful gradation or blotting, unevenness, and more.

In addition, expressions may vary depending on the medium with which you draw the outlines of your painting. There are various media to choose from, such as water-soluble ones, and more. It may not be a problem if colors are blotted with some water, except when the outlines become blotted and dissolved in water. Moreover, you need to choose art media carefully because there are some types of paint that are dissolved in solutions other than water, such as alcohol-based markers, and others.

We tend to overlook the importance of water since we are so accustomed to using it, but understanding its characteristics and mastering its use can make a difference in painting.

Understanding the Characteristics of Paper

Next to mastering the use of water in painting is understanding the characteristics of paper. Paper can either be water-absorbent or nonabsorbent. For instance, colored inks, which should be dissolved in plenty of water, are not suitable for Kent paper; and the powder of colored pencils and pastels does not absorb well on paper.

For watercolors, highly absorbent watercolor paper works well. Markers can produce different effects of texture and unevenness, and the ink is absorbed differently depending on the quality of paper. So you should try to apply ink on various types of paper and discover your favorite type.

Stretching Watercolor Paper

If you have done a watercolor painting, you have seen how the paper became rugged when water was applied and was no longer comfortable to draw on. The painting may not have been finished well as a result.

To avoid the above result, you can soak the paper well in water in advance, stretch it, and pin it up on a panel. Draw a picture on this paper with plenty of absorbed water, and the paper will remain neat and straight when it dries.

Some people use a board because it is simple, but the board itself warps when it absorbs water, and you may not necessarily find an appropriate board for the paper of your choice.

Master the stretching technique because it can be applied to any type of paper.

Materials to Prepare
Wooden panel or board
Artist's stretching tape
Brush
Selected paper

Stretching tape is a paper tape with glue on the wrong side. Like a postage stamp, the glue becomes an adhesive when it absorbs water, but dries easily. Once the glue dries, it will no longer stick. So cut the tape into a desired length in advance, and finish the work as quickly as possible.

1. Cut out the stretching tape in advance into a longer length than that of each side of the paper.

2. Apply water thoroughly on the wrong side of the paper with a brush. Spread water evenly in the corners.

3. Turn the paper upside down, and paste it on the panel. Use your hands or a sponge to stretch it thoroughly, trying to prevent air from entering. Do not rub it in various directions because the paper may wrinkle; rub it toward the same direction.

4. Apply water quickly on the stretching tape with a brush. Water dissolves the glue on the tape.

5. Press the stretching tape onto the paper to stick it on the panel. Rub and stretch the paper carefully each time you paste one side of the paper. Wait until it dries, then start drawing a picture. When you finish drawing, cut the tape with a knife, and take the paper off the panel.

Place some water and paint before it dries up, so that the paint appears soft and blotted.

Mix a thick paint with a little water, so that the touch appears strong and lively. The trace of the brush also becomes clear.

When paint is diluted with a lot of water, the touch becomes soft and natural.

When water and a color are applied, and another color is overlaid, the colors blot and create an interesting texture if you work on it before it dries.

When a color is applied over the surface with water, it will attain a sense of transparency.

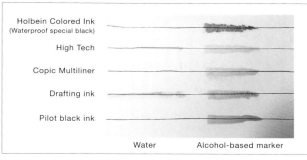

	Water	Alcohol-based marker
Holbein Colored Ink (Waterproof special black)		
High Tech		
Copic Multiliner		
Drafting ink		
Pilot black ink		

The diagram above shows the result when water and an alcohol-based marker are applied over pen and ink, which are frequently used for drawing principle lines. The blotting effect is examined, and the ink dissolves in different ways depending on its properties.

Painting a Wide Area Without Unevenness

It is not always easy to paint evenly on a wide area. The following pointers explain several painting methods for achieving this.

Paint Before It Is Completely Dry
Apply colors quickly with water before they dry. When you soak water into the paper, use a wide brush or other tools to apply the water quickly because the paper dries out from the edges if you take too much time. Try to finish the work carefully but quickly.

If the paper absorbs too much water, wipe off the excess water with tissue or use a hairdryer to adjust the moisture.

Use a Thick Brush
A thick brush works best for painting a wide area. A brush or a roller can also be effective. It is best to have various sizes of brush on hand for different purposes.

Paint Several Times
If your painting is intended to be flat, try to paint several times in order to remove any unevenness. When you use a marker to paint a wide area, you should use a nib that is as wide as possible since it tends to become uneven, or you should let the paper absorb ink before it dries completely. Again, work quickly.

It is also good to apply ink over a layer that is not completely dry, or you can use colorless ink to make a beautifully colored layer with a blot effect.

Consider the Order of Painting
The order of applying your paint media determines how colors settle when you use two or more kinds of media with different properties. You should consider which color to apply first when you combine media with two different degrees of transparency. This will tell you whether the color underneath will show through the overlying color.

When using an alcohol-based marker and an aqueous marker together, the colors can be drawn evenly if you apply the alcohol-based marker over the aqueous marker. But the colors will become uneven if you apply them the other way around.

It's important to remember this in order to create a smooth surface, unless you use a texture effect on purpose.

Expressing a Watercolor Touch Without Difficulty
There are various kinds of paint media that can be dissolved to express a similar touch to watercolor painting. Try different media, since any paint with *watercolor* or *aqueous paint* in their names can blot on paper.

Watercolor Pencils
In order to achieve a beautiful color, apply water onto the pencil's powder as you dissolve it. Lay down the pencil to paint a wide area, or dip a brush soaked in water on the powder of the pencil, and you will be able to achieve the effect of a watercolor painting.

A thin line drawn strongly may not be dissolved in water, so you should try various types of touches.

Watercolor Crayons
Watercolor crayons are also used, like watercolor pencils, to color the paper with a soft touch by applying water over it. Crayons will produce an interesting effect that is slightly different from what watercolor pencils give. Vivid colors and textures are features of watercolor crayons.

Aqueous Markers
Draw lines strongly with an aqueous marker on the palette and dissolve the color in water to create a good watercolor effect. You can try this method when you cannot find your favorite color in your color collection.

However, this technique cannot be tried on paper because paper absorbs ink before the ink is dissolved in water. Instead, a palette or paper palette is good for this method. It can also aid you in creating light and clear colors. Try to mix a variety of colors.

Water Brush
You can dissolve the hues of watercolor pencils or aqueous markers and paint at the same time using this

kind of brush. Like a cartridge writing pen, this brush absorbs water so that you do not have to worry about water. It is handy for sketching in the open air or for using solid paints.

When painting a wide area, paint it quickly with a brush. It is important to work on the painting before the paint dries.

When painting a wide area with a marker, paint the surface several times or use a marker with a brush or a wide nib. (Photo: Copic Wide)

A watercolor pencil can express a soft touch. It consists of the same features as both colored pencils and watercolors.

A watercolor crayon can produce rough textures compared to a watercolor pencil, and the colors become sharp.

By dissolving aqueous marker in water, you can enjoy painting with a watercolor effect.

Overlaying Colors

It important to see whether paints show through an overlaid color or not. This section shows some examples of a dark color (blue) laid over a light color (yellow), and vice versa. The ability to cover one color differs according to the material used.

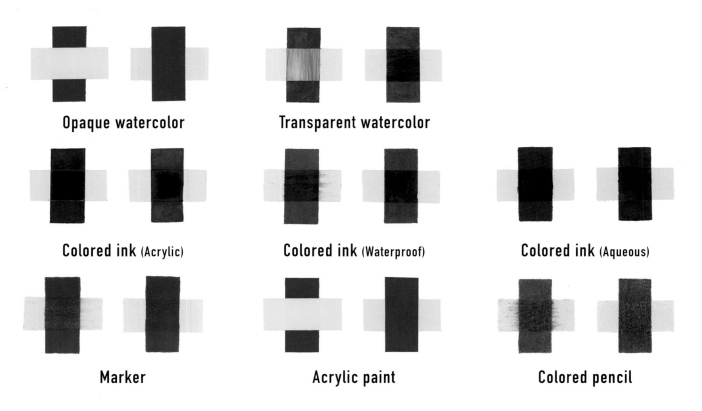

Opaque watercolor Transparent watercolor

Colored ink (Acrylic) Colored ink (Waterproof) Colored ink (Aqueous)

Marker Acrylic paint Colored pencil

Color Gradation

Gradating and blotting colors with water are frequently used techniques. The blotting technique, when done well, helps to produce a natural gradation. This section illustrates several comparisons of blotting with a barely diluted solution (upper bar) and with a water-diluted solution (lower bar).

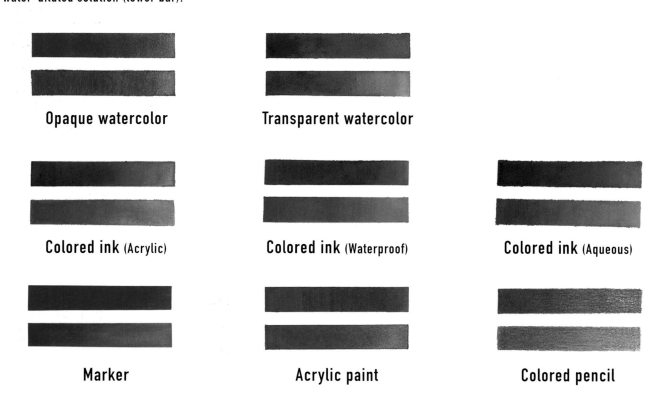

Opaque watercolor Transparent watercolor

Colored ink (Acrylic) Colored ink (Waterproof) Colored ink (Aqueous)

Marker Acrylic paint Colored pencil

Brush

Brushes are important painting tools. If you are using a cheap brush or one with an uneven tip, you may not be able to paint with a good stroke. Understanding the function of every type of brush will help you know which kind you need to buy. There are soft and hard brushes, and many more types than those introduced in this section. Other options include a line-drawing brush, a paintbrush, a slashing brush, and a makeup brush for Japanese-style painting.

Round
The round brush is a cylinder-type brush that expands softly if it is soaked in water. It is also suitable for painting details.

Fan
This brush has a fan-shaped tip and is suitable for expressing fur, blotting overlaid paints, spattering, and other effects.

Angular
The angular bush has a diagonally cut tip. It is better for bold designs than a flat brush. It is also suitable for drawing circles or curves.

Filbert
The filbert brush has a shape similar to that of a flat brush, except both angles at the tip. It has also the characteristics of both the flat and the round brush, and is very handy.

Flat
The flat brush has a flat tip. It can draw a sharp line with edges and is suitable for long strokes as well as painting a large area.

Paper

Paper is an important material for drawing. Every type of paper has its own characteristics: good absorption, bad absorption, roughness, fineness, and more. Paper has a close relationship with paint, and if the combination of paper and paint is not good, it may not be possible to achieve the intended effect.

Watson
The paper in Watson watercolor blocks is made from cotton fiber. It is yellowish in color, and its surface is slightly rugged. The pen may easily get caught in it. Ink is easily blotted on it, and the colors come out sharp and rich.

Kent
Kent paper has a slick and smooth surface. You can draw a smooth line on it with a pen and not worry about the pen getting caught in it. Kent is inexpensive and available anywhere, but it does not absorb ink well, so it may not be appropriate for watercolor.

BB Kent
BB Kent paper comes in two types: rough and fine texture. The pen does not get caught in it. It absorbs ink fairly well and the colors come out sharply. It is cheap and available anywhere, so you can try applying various inks on it. It is used for manga book pages and covers.

Arches
This high-grade watercolor paper has two types: rough and fine texture. Blotting expands delicately. The color settles well and comes out sharply. A pen can easily get caught in this type of paper, and replacing it could be expensive, though this paper is very popular among professionals.

Homo Drawing Book
This drawing paper (the same as Strathmore paper) is available at almost any stationery shop. It absorbs ink sufficiently, and the paint also blots and produces sharp colors. It is cheap, handy, and widely used.

Fabriano
Fabriano watercolor paper absorbs paint well, and the paint blots beautifully. Howvever, the pen can easily get caught in it. There are two types: rough and fine texture. The colors come out soft, and they are retained well.

Canson
The Canson watercolor paper does not blot much but colors are lively. It has a strong resistance to water and does not easily become uneven. It is often sold in blocks and is fairly easy to obtain.

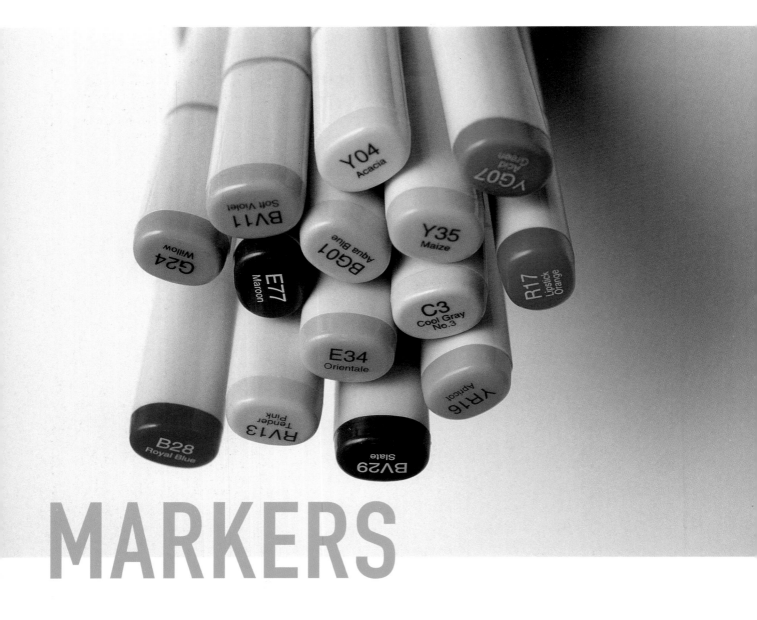

MARKERS

What is a Marker?

A marker is a paint medium that comes in various colors and takes the shape of a pen. You simply take off its cap in order to draw. Many markers can now be found with brush-type nibs, which are suitable for painting that covers a wide area and includes details. A marker is applicable to a variety of techniques and does not make a mess. It is a multipurpose and handy tool that is highly effective.

Characteristics of Markers

Originally, color markers were mainly water based or oil based, except for Copic markers, which are alcohol based and do not dissolve the toner of photocopiers. It also passes through the underlying color, so it is used as one would use transparent watercolor.

Like a felt-tip pen, an oil-based marker does not fade and blot so much. A water-based marker can be dissolved in water and used like watercolor. The oil-based marker becomes waterproof when it dries.

Letraset Tria Pantone markers, which come in beautiful colors, used to attract many earnest fans among professional artists, but Copic markers have become more popular recently.

One of the characteristics of Copic markers is their variety of colors and related products. Copic Sketch Series has a lineup of as many as 310 colors, ranging from extremely light to bright and dark colors.

Moreover, if you mix a color of Various Ink refill, you can create your own color.

Marker Techniques

A marker is relatively easy to draw with, but it sometimes produces a rough texture. It is difficult to draw a wide area evenly with it except with one that comes with a brush-like nib. Yet, drawing with a nib-type marker may also not be easy, especially if you are not skilled at using it.

A wide area can easily become uneven with a marker. You need to paint it over several times to fill in the unevenness. It will become smooth as the ink soaks into the paper. It is also important to paint before it dries.

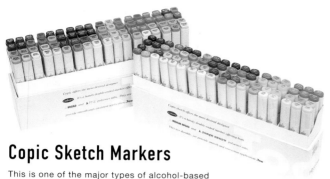

Copic Sketch Markers

This is one of the major types of alcohol-based markers that do not dissolve the toner of photocopiers. At present, 310 different colors are available, and it is famous for producing good variation and color sharpness. Since it is alcohol based, you can use for a blotting effect. It is also popular because it has many related products. The ink can be refilled with Various Ink; its different colors can be mixed to obtain your own original ink.

Maxon Comic Twin

This is an alcohol-based marker with two types of nibs: a brush that effectively expresses the brush texture, and another that has a fine nib suitable for detailed designs. It has vivid colors that do not darken even if another color is laid on top. At present, 144 colors are available, and there are color assortment packages for different usages.

http://www.maxon.com

Copic Opaque White

This type of marker becomes waterproof when it dries, and the underlying color does not blot. It is used not only for Copic products but also as a general whiteout. It spreads well and is handy.

Copic Multiliner

This type of alcohol-resistant marker can be overlaid with an alcohol-based marker, such as the Copic Marker. The sizes of the tips range from a 0.03 point to a 1.0 point; there are also brush-type liners.

Copic Airbrush Kit

This is an excellent tool for producing effects that are difficult with Copic markers. This Air Can is attached to a Copic ink. It sprays air on the nib of a Copic marker and is used as an airbrush.

Copic Various Ink

This is a refill for Copic Ink. The ink of the markers can be refilled with this product. Moreover, a few colors can be mixed in an empty bottle to create an original color.

Be careful when you use markers that have different properties. The ink of water-based markers dissolves in water, so the colors are blotted when you overlay different colors. An alcohol-based marker produces a rough texture, but you can use it as a special effect. However, if you want to create a beautifully painted area without unevenness, you should first paint with an alcohol-based marker, then with a water-based marker.

Points in Using a Marker

A marker dries easily, so the cap needs to be closed firmly. Paintings drawn with a marker should be kept away from direct sunlight because markers discolor fairly quickly.

When the ink of a marker fades or no longer spreads evenly, replace the marker itself with a new one or refill the ink. Some types of markers have spare nibs, so you can change the nibs when they are no longer effective for drawing.

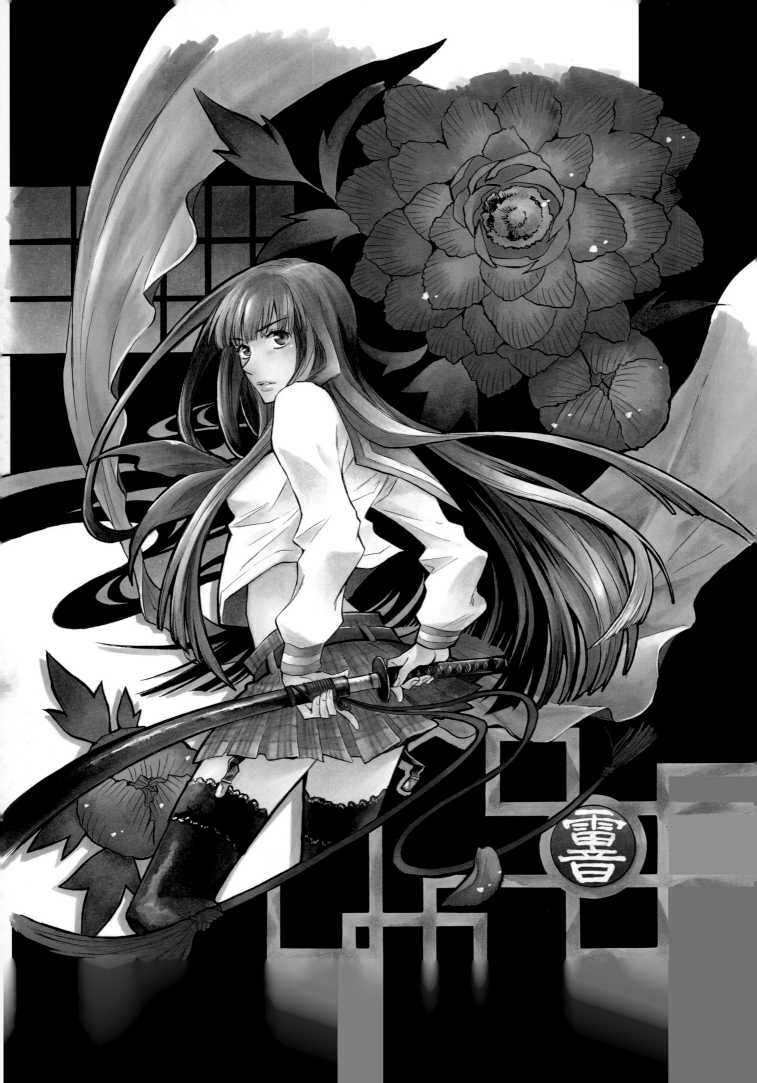

Saya Iwasaki
いわさき砂也

Saya Iwasaki is a comic book artist and illustrator. She is actively engaged in producing comic books and game anthologies.

Photo by Yoshiharu Watanabe

step1 **Rough**

Saya has drawn the sketch representing autumn, using a pen for the outlines and a Copic marker to indicate the flow of the hair.

step2 **Skin 1**

Using Copic markers, she fills in the color. She applies dark and bright colors to the skin, then continues with light colors.

step3 **Skin 2**

She overlays darker colors gradually. "I painted it to make it look beautiful," she says, smiling.

step4 **Skin 3**

She does not rotate or move the drawing when coloring. "If I place it flat on the surface, it is easy for me to check the picture balance," she says.

Saya Iwasaki
いわさき砂也

step5 **Skin 4**

Then, Saya applies color to the hands. She overlays colors gradually as she did for the faces.

step6 **Skin 5**

She works on the hands and examines their position, while focusing on the color differences in the shadows. "I look at the entire balance once again after I finish everything."

step7 **Hair 1**

Next, she colors the hair. She first applies light colors as a foundation for other colors.

step8 **Hair 2**

She balances the hair tone with shades and uses a pen to express the flow of the hair, chiefly by outlining a large section of hair to show direction of movement.

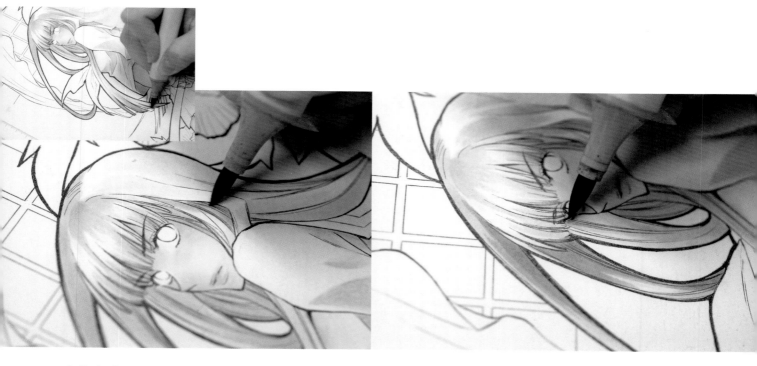

step9 Hair 3

When she has finished painting the entire drawing, she applies darker colors to add color tone in different areas.

step10 Hair 4

She uses darker colors to indicate the contrast of light and shade. The drawing now resembles a 3-D image.

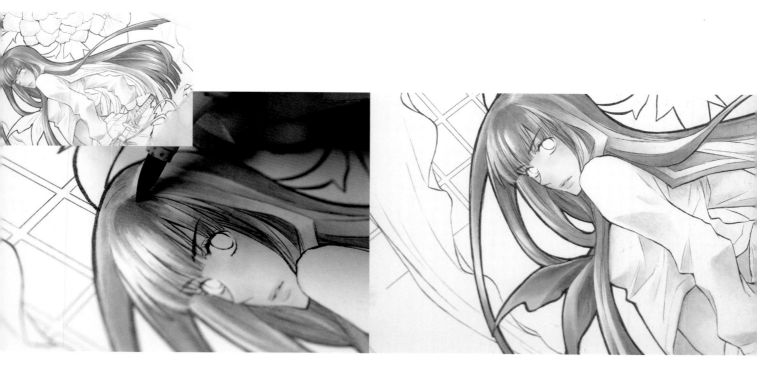

step11 Hair 5

She introduces brown, which is the main color in this drawing. Brown against the previously applied gray makes the picture sharper and gives it more contrast.

step12 Coloring the Clothes

Saya colors the sailor blouse. The cloth is white, so she just needs to add some shadows. Some red and brown accents will increase the brightness of the drawing.

Saya Iwasaki
いわさき砂也

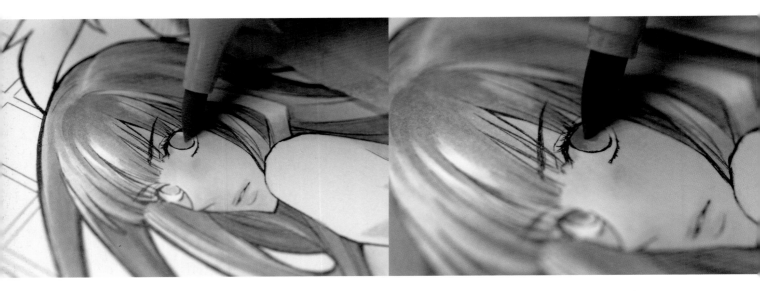

step13 Pupil 1

Next, she colors the pupils of the eyes. After thinking, "What color should I use?" she takes out a dark blue.

step14 Pupil 2

She marks in the foundation with a light color, then overlays the other colors.

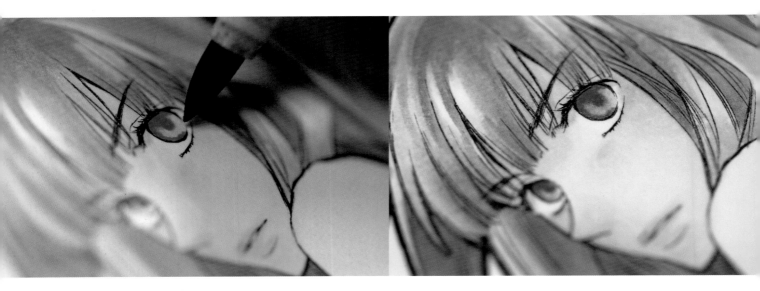

step15 Pupil 3

To achieve good contrast, the shadows in the eyes are filled in first.

step16 Pupil 4

Then, she blurs the borders to merge the elements naturally. "I add white when the other parts are all painted."

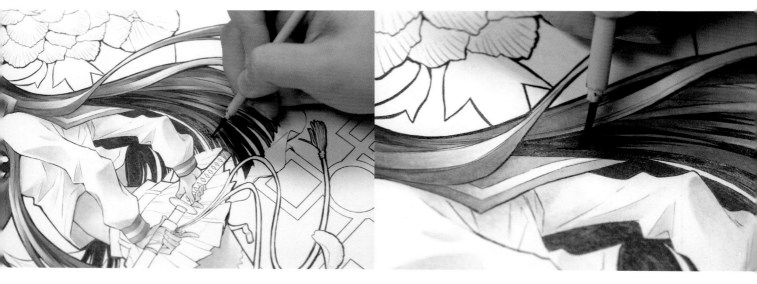

step17 Detail Coloring 1

Now, she puts down the marker and takes out a brush to paint evenly with ink.

step18 Detail Coloring 2

She uses a fine brush and paints in one direction in order to avoid unevenness.

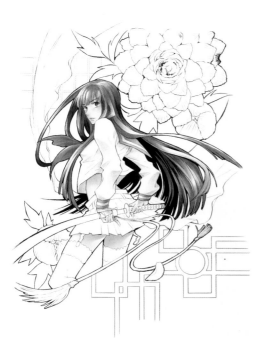

This is what Saya's desk looked like after the photo shoot. She always compares the colors of the drawing and the markers, then picks up the colors in her hands to see which one works best.

step19 Detail Coloring 3

Adding black makes the painting sharper and more vivid. Then, she works on the background and applies more colors, checking the picture balance as she goes.

Colors Used for Characters

E41	YR20	CM68	C3
E50	E02	YR24	BV20
E000	E21	BV31	BV04
E00	E43	B93	B63

COLORED INK

What is Colored Ink?

Colored ink is sensitive, produces vivid colors, and works perfectly with water. It spreads and blots well, thus, it creates a clear and delicate texture. However, it discolors quickly and needs to be stored carefully to last. It also comes in various fun bottle shapes.

Characteristics of Colored Ink

Unlike transparent watercolor, colored ink is made with pigments and dyes, so it is highly transparent and does not create unevenness.

The color tone is so sensitive that many people do not mix these colors because mixed colors tend to be cloudy. Many manufacturers have invested in producing highly saturated colors. You can mix a lot of water with the ink and then paint quickly.

As a liquid material, it can be used not only with a brush but also with a pen. Thus, it can be applied to calligraphic letters. Some types of ink are made from pigment and have some adhesiveness, and thus, can be used with an airbrush.

There are other types of colored ink with different characteristics, such as an aqueous type made from dye, a waterproof type (when it dries), an opaque type, and more. You can use these varied characteristics freely for drawing principle lines, painting in layers, or other elements of a painting or drawing.

Colored Ink Techniques

One of the basic techniques of colored ink is the use of water. To paint a wide area, you first soak water into the paper, then paint colors swiftly with a thick brush until the color settles into the paper. Of course, you can also paint without water, and you'll be able to create your favorite texture.

It is best to proceed from light to dark colors because you can check and adjust the color coordination as you paint along.

You may need a certain number of brushes for expressing several different delicate textures. These brush types could be: a large brush to paint a wide area, a fine or line-drawing brush to paint details, and

Winsor & Newton Drawing Ink

This ink color is bright and clear. It spreads well and is waterproof, so it is also good for drawing principle lines. It has a wide-mouth bottle and an appropriate volume.

26 colors, .5 oz (14 ml)

Talens Ecoline Liquid Watercolor

This ink is characterized by clearness and color saturation. It is water soluble but becomes matte when it dries. It spreads well and is easy to handle.

47 colors, .7 oz (20 ml) and 1 oz (30 ml)

Dr. Ph. Martin's Pigment

This colored ink consists of pigments that are sticky. Since it is mixed with acrylic resin, it becomes water resistant and opaque when it dries. It spreads and settles well in water, and can add some interesting effects to the painting.

73 colors, .5 oz (15 ml)

Dr. Ph. Martin's Colored Ink

This is one of the most popular colored inks, which produces bold colors and spreads well. The company's Radiant ink can be diluted with water, while Synchromatic ink can be painted on photo film and has a high degree of transparency. Both types are water soluble.

Radiant ink
56 colors, .5 oz (15 ml)
42 colors, 2 oz (59 ml)
Synchromatic ink
38 colors, .5 oz (15 ml)
38 colors, 2 oz (59 ml)

Holbein Drawing Ink

This is a highly water-resistant ink that can be used for drawing principle lines. It spreads well, hardly discolors, and is smooth, so it is suitable for laying one color on top of another. Special colors consist of pigments and are opaque.

Standard, 28 colors, 1 oz (30 ml)
Special, 7 colors 1 oz (30 ml)

Pelikan Drawing Ink

This highly transparent ink has a collection of particularly chic colors. It is very smooth and spreads well. Since it is water resistant, it can be used for drawing principle lines.

12 colors, .3 oz (10 ml)

others. It is not a good idea to use only fine brushes if you want to utilize different features of the paint media. Water should also be changed frequently because you are using very delicate colors.

Texture effect and blotting may differ depending on the quality of the paper. You may have a paper preference, but you might want to utilize a paper that absorbs water well, such as watercolor paper.

Points for Applying Colored Ink

The most important point for applying colored ink is discoloration. If your work is not properly preserved, it will discolor gradually. Colored ink itself discolors, so it needs to be stored in a box that shuts out direct sun and stored in a cool, dark location. Once the bottle is opened, the ink deteriorates as time goes by. The ink can even dry up after three years or more. It sometimes becomes muddy, so you should not wait too long before replacing it.

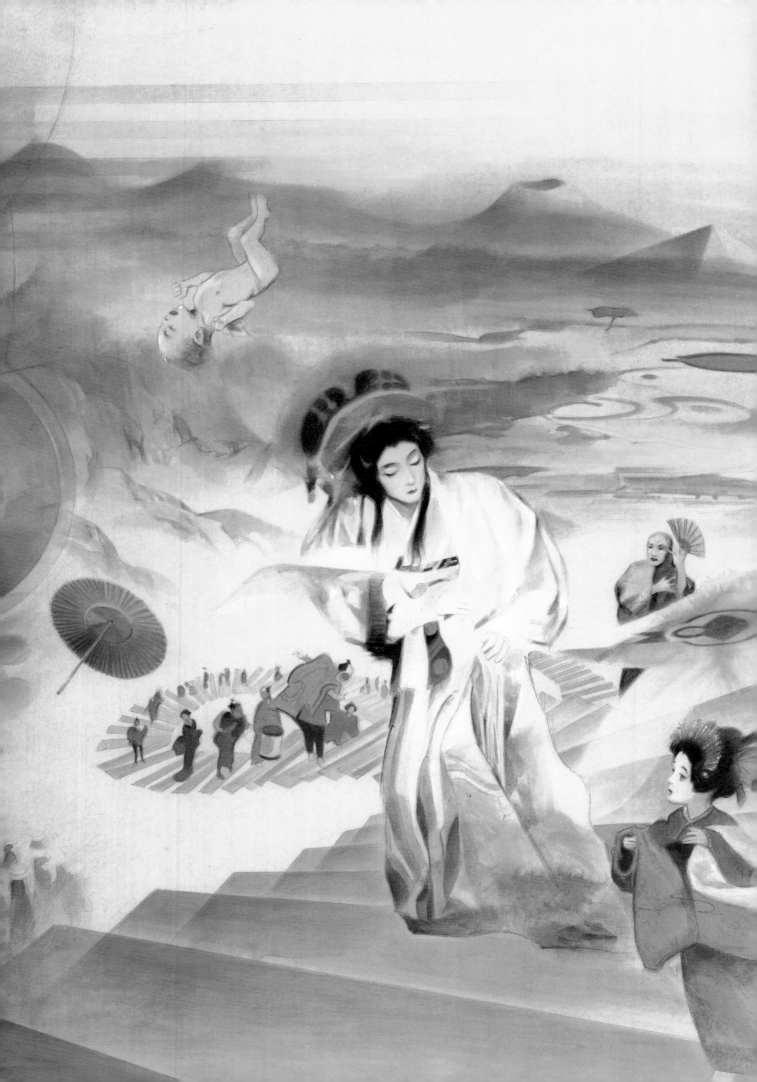

Hiroki Mafuyu
ひろき真冬

Photo by Yoshiharu Watanabe

Born in Japan, comic book artist and illustrator Hiroki Mafuyu is well known for "Louise" (Shinchosha), "Etiquette of Violence" (Asahi SONORAMA), and other works.

Web site:
http://hirokimafuyu.com

Picture Scroll Series: Space Oiran

Hiroki Mafuyu has featured his serial illustrations, Space Oiran, in *Comickers* magazine. For this volume, he drew the third series, and documents his process of production.

Space Oiran was originally supposed to have four titles in a series. There is a logical development in the story as a whole, and gorgeous processions of courtesans trail through picture scrolls. For the first serial, Hiroki Mafuyu drew courtesans who emerged from a strange space (right). For the second serial, (below), people came out of a strange space-time entity and joined a long procession. One can see a palace with a jaguar's head above it. In the third serial (see pages 68–69), the procession finally enters the palace. A courtesan approaches the throne, and she entrusts a baby. How will the story develop in the final serial of Space Oiran?

You may have noticed some illegible writings that looked like Chinese characters at the edge of the illustration in the first serial. Those were Hiroki's invention; they did not mean anything and did not form a sentence. He simply inserted some keywords or characters so that readers could use their imagination to create their own stories.

The production process for Hiroki's works reveal his detailed works of art, which include many different messages and stories for each reader. Enjoy.

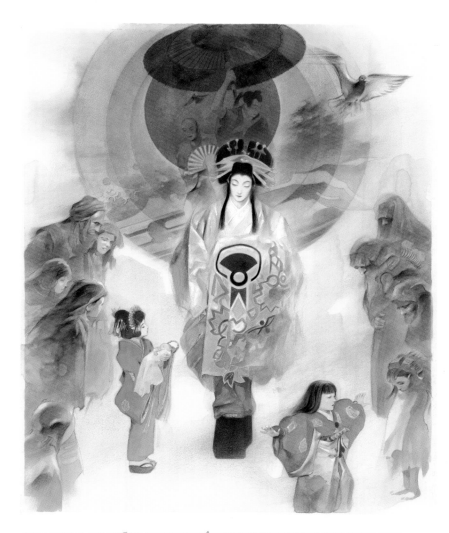

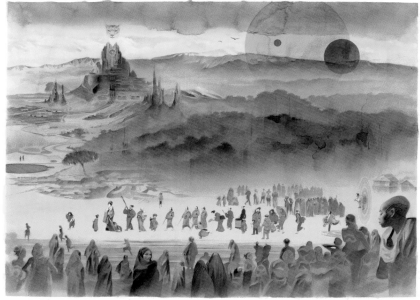

Hiroki Mafuyu
ひろき真冬

Background Sketch 1: Sepia

Draw a background sketch with a pencil and colored ink. This task is important to determine the tone of your whole illustration. A well-drawn background sketch helps produce a strong composition.

step1

Draw a background sketch with a pencil (#4 or harder) on Arches paper, while referring to your rough drawing. Draw the details carefully.

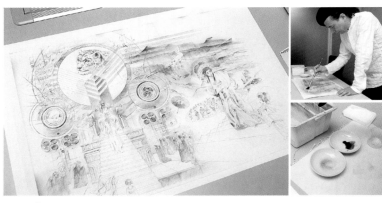

step2

Soak a lot of water in a very thick brush. Using sepia (Holbein colored ink), first try to apply it on trial paper, then sweep the paper thoroughly with it.

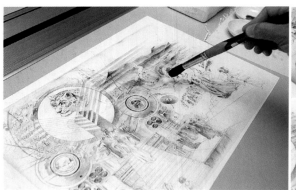

step3

Using the same sepia color, add some rough tones in the illustration. Use Holbein colored ink through to the middle stage of your background sketch. The colored ink is waterproof and is used for the background sketch because it does not run.

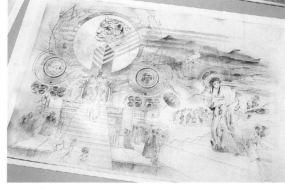

step4

When you use a lot of water, the background sketched in with pencil starts to run. You can ignore this and continue to lay the colored ink.

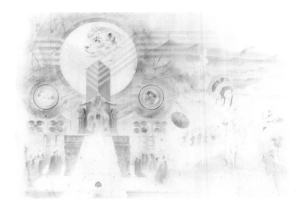

step5

This is an illustration roughly done with sepia.
Hiroki calls this stage "sepia painting."

Hiroki Mayufu mainly uses colored inks, but he also chooses various types of paint media in order to add depth to his illustrations.

Background Sketch 2: Yellow, Orange

When the sepia color dries, continue to overlay other colors. At this stage, paint with brighter colors, and consider the light and dark areas.

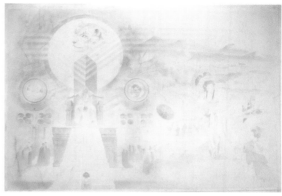

step6

After the sepia painting dries, take some Mexican yellow (Holbein colored ink), then dissolve it in a lot of water before painting.

step7

Above, the background is finished with Mexican yellow. Do not apply the color all over, as was done for sepia, but arrange the tones in the painting with a dominant color.

step8

Then, overlay a Mexican yellow that is darker than that in step 7. Overlay the color before it dries in order to get a beautiful blotting effect.

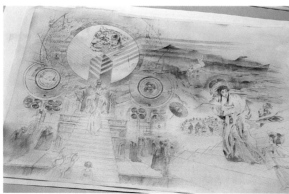

step9

A darker color is applied to areas that need to be emphasized. The tone is differentiated between the right and left side. The painting, then, becomes lively.

Hiroki Mafuyu
ひろき真冬

Applying Colors Roughly

When the background sketch has been painted, apply other colors lightly to arrange the tonality. When it is roughly done, apply some key colors in the areas that need to be emphasized.

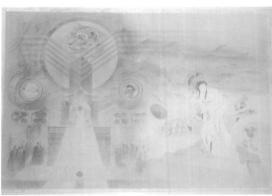

step10

After the background colors dry, apply a thin layer of yellow and blue. As you check the overall tonality, paint further, taking care not to make the composition too dark.

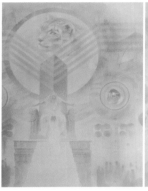

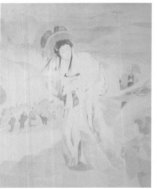

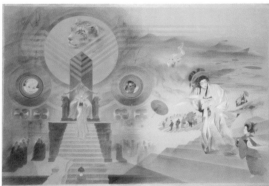

step11

Overlay colors onto points where you have used primary colors: red, yellow, and blue. Carefully color the people and the other small details.

step12

Use Dr. Ph. Martin's aqueous colored ink in places that will be painted with bright colors. Do not overlay colors, but try to show the color as it is.

Paint Details

Use colored pencils or Copic markers, instead of colored inks, for coloring in the details. Paint the entire drawing as you try to fill in the colors.

step13

After laying down the major colors, use a Copic marker to fill in each part of the drawing.

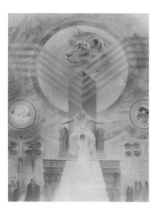

step14

Overlay light Copic colors, such as C0, W0, or R00, which are light enough to fill in the texture of the paper that the watercolors have not covered.

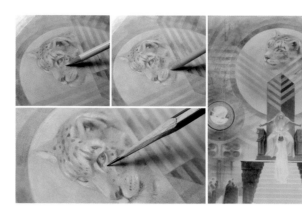

step15

Also, use colored pencils to add texture along with the Copic colors. Draw the texture of objects, alternately using Copic and colored pencils.

Motif 1: Jaguar

Express the texture of the fur with frequent strokes of colored pencils. Do not use watercolor pencils. Use colored pencils over and over to make the picture richer.

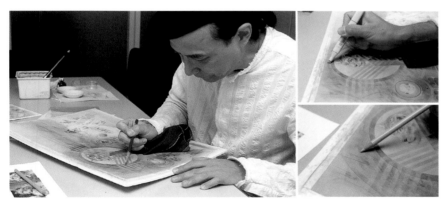

step16

Express the texture of the jaguar's fur with golden yellow, pale orange, and other colors. Sometimes, you can add lines with #2 pencils or harder.

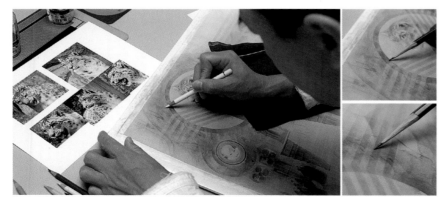

step17

Draw the jaguar carefully while checking photos and other references, which professional artists never fail to use.

Hiroki Mafuyu
ひろき真冬

Motif 2: Throne

The throne is an important motif associated with the next story. Apply a hue that's different from the right side of the picture so that it exudes a certain solemnity. This deep tone is the result of layered colors.

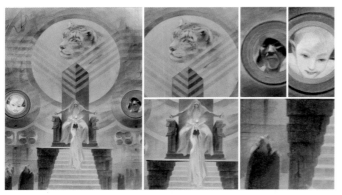

step18

Copic markers are used for the basic colors. Then, try to settle the colored ink into the paper as you add light colors.

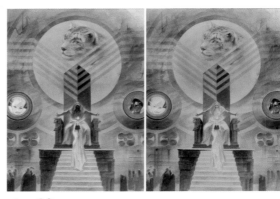

step19

While arranging the light's tone on the drawing, add colors randomly. Change the tonality of the dark places in order to draw the light.

Motif 3: Courtesan

The courtesan is the most important character. Work on the background carefully so that the light gathers around her. A delicate drawing technique will boost her importance in the painting.

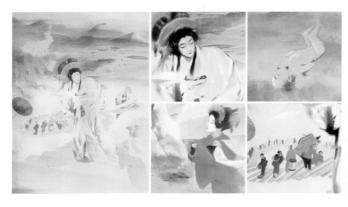

step20

The courtesan consists of bright colors. Work and paint very carefully with a sensitive touch. Try to arrange the overall color tonality so that the focal point of the picture is the courtesan.

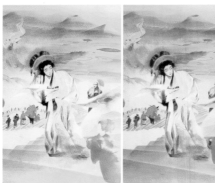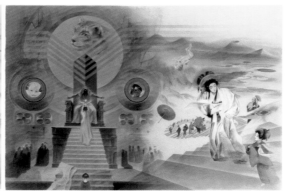

step21

While considering the texture of the kimonos, overlay colors gradually so that the colors appear to be at the same time transparent and rich. Arrange the total color balance to finish.

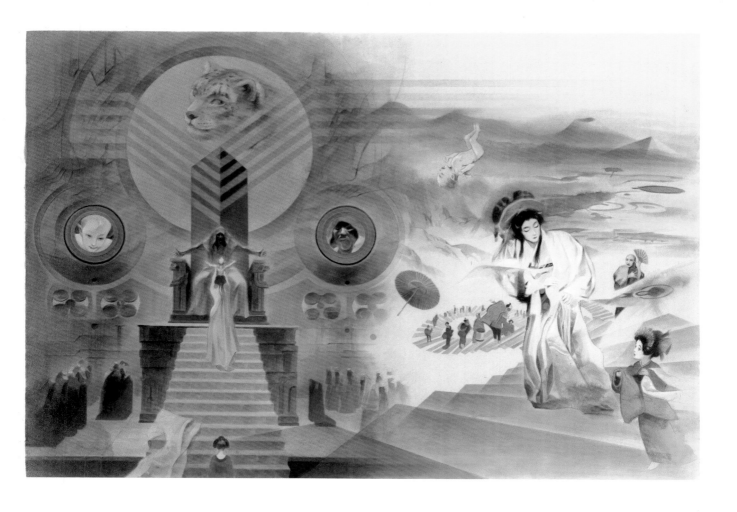

Tools

Hiroki's favorite paint media and materials: Dr. Ph. Martin's Radiant colored ink, Holbein colored ink, Copic markers, Tria Pantone markers, and Steadtler colored pencils. He also prepares reference materials, as needed, for drawing pictures, for background music (BGM), and for other elements.

TRANSPARENT WATERCOLOR

What is Transparent Watercolor?

Transparent watercolor is a highly transparent paint that does not hide base colors when several colors are laid over. Its colors are not as saturated as those of colored ink, but one of its appealing features is the colors' ability to be easily mixed and handled. It spreads well and produces bold colors.

Characteristics of Transparent Watercolor

Transparent watercolor is water soluble and non-water resistant.

A base color can be seen through another color, which makes it possible to show various other colors. The paint that does not show through an underlying color is called opaque watercolor, or gouache.

Unlike the colored ink, the colors of a transparent watercolor are less sharp and less spreadable, but its chic colors are very characteristic of transparent watercolor. However, be careful when mixing colors because the effect becomes cloudy if too many colors are mixed together simultaneously.

Transparent watercolor is made from pigments, so it tends to become uneven when painted on a wide area, but you can utilize this feature to create your own texture or make many interesting layers of colors. It also allows you to make effective use of the paper's texture.

Transparent Watercolor Techniques

One basic technique in bringing out transparency in this type of paint is to dilute it in water and paint it over and over. It can be mixed with other colors on the surface of a painting.

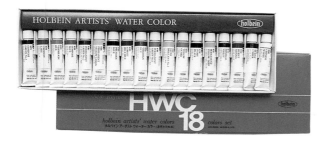

Holbein Artists' Watercolor

The ingredients of this paint are: pigments and the medium of gum arabic. It is highly transparent, and pencil and pen lines can be seen through this paint when diluted in water and painted over. When painted over repeatedly, the effect is that of mixed colors.

.2 oz (5 ml) and .5 oz (15 ml) tubes

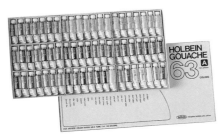

Holbein Artists' Gouache

63 colors
Holbein Works, Ltd.
http://www.holbein-works.co.jp/english/

Winsor & Newton Artists' Watercolor

96 colors
Winsor & Newton
http://www.winsornewton.com/

Choice of Paper

The type of paper is especially important when using watercolor since this type of paint requires a lot of water. There are various kinds of watercolor paper that directly affect the artistic expression of your work. They are, however, relatively expensive, but they have high-quality coloring, resistance, and texture. One of the major types of watercolor paper is gouache. Other types are shown below.

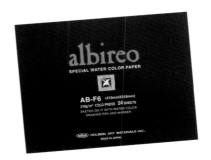

Albireo

It has a durable surface that shows colors clearly. It has low and reduced absorption power and is effective for artwork that requires smooth coloring.

218 g (7.7 oz) • Normal thickness • Medium texture
Available in notebooks, books, blocks and postcards

Holbein Art Materials, Inc.
http://www.holbein-works.co.jp/english/

Clester

This is a natural white or cream-colored paper that tones down colors when painted. It absorbs water well and is suitable for beginners.

210g (7.4 oz) • Normal thickness • Medium texture
Available in notebooks, books, blocks and postcards

Holbein Art Materials, Inc.
http://www.holbein-works.co.jp/english/

It is water soluble, so it is very effective for creating a blotting effect on paper. You can also try to make a beautiful blotting or gradation effect on watercolor paper.

Transparent watercolor paint is sold in tubes, so it is handy and keeps well for a long time. It discolors, although not as much as colored ink, so watercolor paints and any painting made with them should be stored in a cool, dark location.

Transparent vs. Opaque

Watercolors can also be opaque (gouache). This means that the paper does not show through the color. Transparent watercolor is basically used to overlay different colors thinly, while opaque watercolor can express bold and deep tones. You can also use a thin coat of opaque paint when you want to lay another color over one you do not want to completely hide. Simply choose the color that suits your taste.

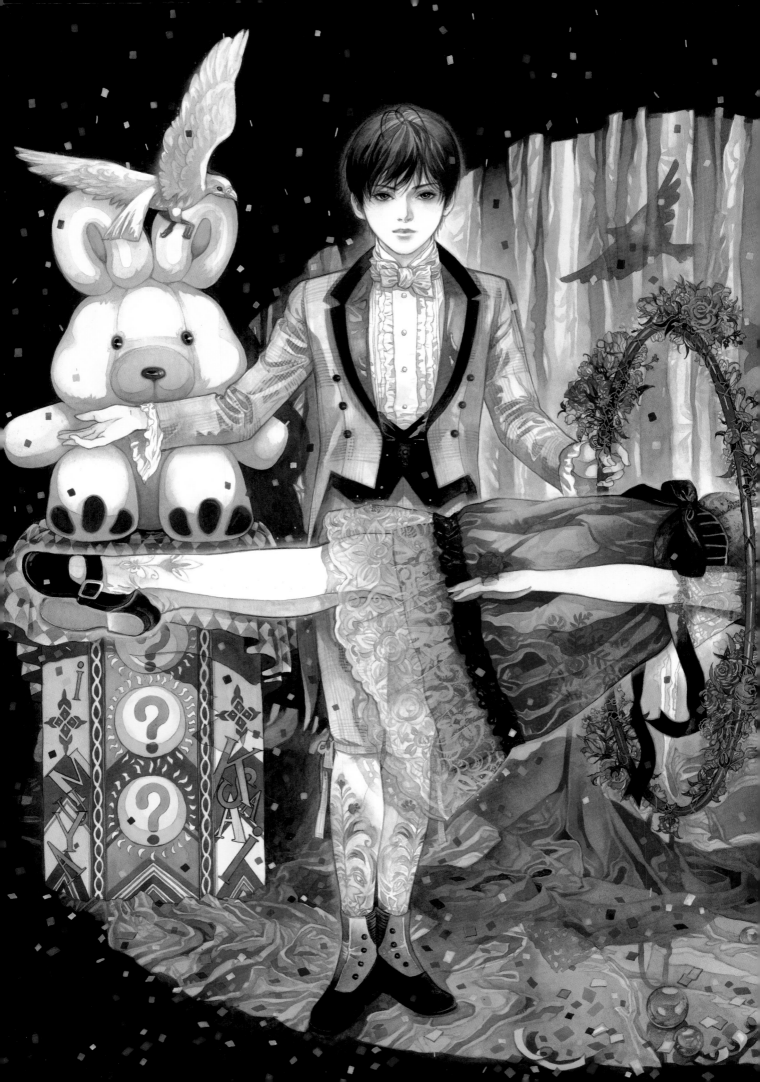

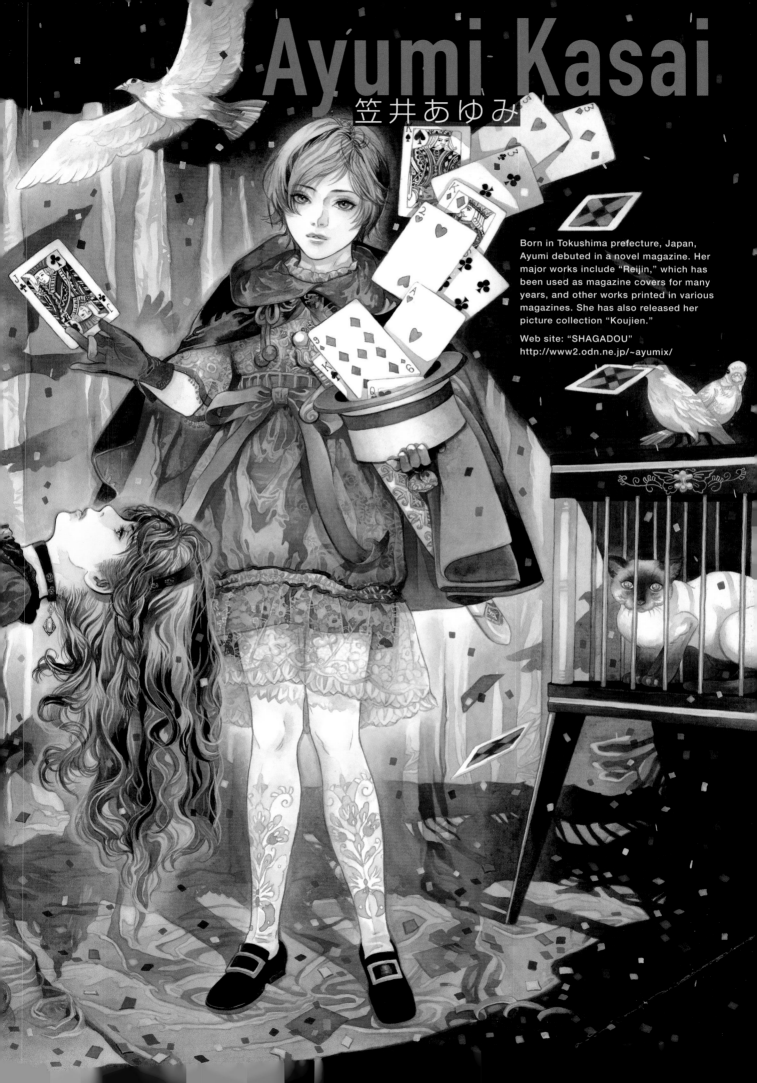

Ayumi Kasai

笠井あゆみ

Born in Tokushima prefecture, Japan,
Ayumi debuted in a novel magazine. Her
major works include "Reijin," which has
been used as magazine covers for many
years, and other works printed in various
magazines. She has also released her
picture collection "Koujien."

Web site: "SHAGADOU"
http://www2.odn.ne.jp/~ayumix/

Ayumi Kasai
笠井あゆみ

Photo by Tadahisa Sakurai

step1 Rough Sketch

Ayumi uses a B #1 mechanical pencil, 0.3 mm lead, for drawing her rough drafts. She draws them on B4 paper and enlarges to B3 paper for tracing. She applies colors roughly with Faber-Castell watercolor pencils. The concept of her work is "Kids Magic Show." This magic show is similar to a school magic festival where students can make a person float in air but cannot summon a lion because they are still kids, so they use a cat instead. Ayumi says, "I think their tricks are simple, like those by Shiro Maggy (popular Japanese magician)."

step2 Basic Painting Method 1

First she paints shadows with waterproof acrylic paints, then colors with watercolors.

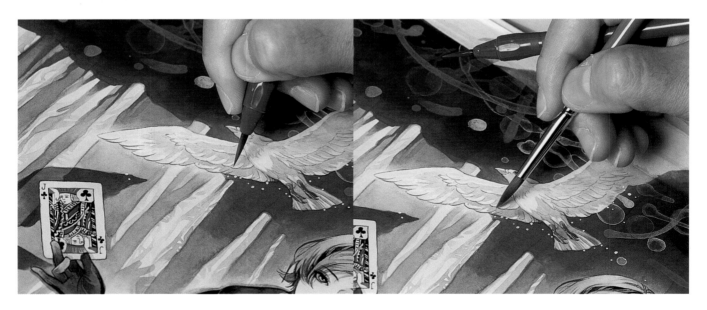

step3 Basic Painting Method 2

She arranges the shadow tones, then she overlays colors gradually while adjusting the tonality and hues.

step4 Basic Painting Method 3

She mainly uses the wet-on-wet coloring technique: Water is applied in the area with a brush for blotting. Overlay the colors with a fine brush, then create a blotting effect on the picture using a water brush. Wipe off excess if necessary, and trace again with the water brush. Repeat.

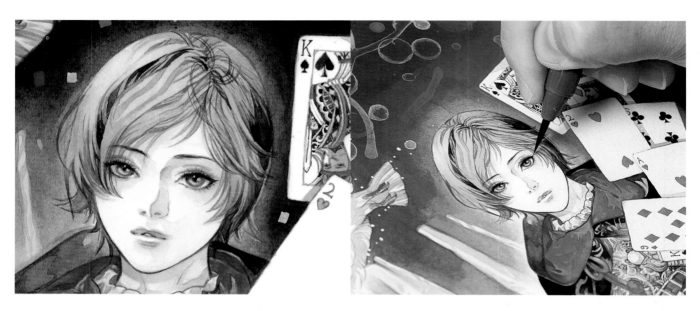

step5 Face 1

To paint the skin, Ayumi dilutes the ivory color and applies it as the foundation. She comments, "It seems that Holbein's ivory has the most beautiful effect for skin color."

step6 Face 2

To paint the shadows around the eyes, she uses burnt umber and French ultramarine, and for the pupils, she uses permanent yellow and burnt umber. She also adds pink under the eyes. Then, she rims the eyes carefully with a mascara-like outline, which she believes is important.

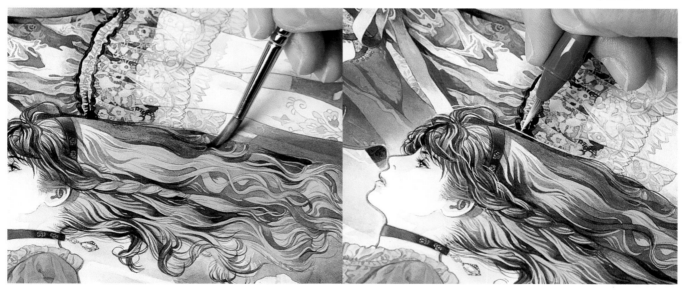

step7 Hair 1

She strokes the picture with water. Then she overlays a Dr. Ph. Martin's pigment, and she stretches the image out with water. She repeats this procedure while applying dark colors and removing them with water in order to accentuate the flow of the hair.

step8 Hair 2

She produces an off-white color using ivory and yellow, then adds highlights in the hair and around the border with the background. She mutes the effect then adds a dark, nearly black sepia.

Ayumi Kasai
笠井あゆみ

step9 Lace pattern 1

Ayumi draws rough patterns for the lacework using watercolor pencils. Then, she paints them with dark colors, which dissolve and erase the lines of the colored pencils, creating a transparent effect.

step10 Lace pattern 2

She remarks, "Although the result is messy, it actually looks like lacework and that's enough."

step11 Lace pattern 3

She continues to overlay the colors. Darker colors bring out the patterns of the lighter colors like an embossed picture.

step12 Lace pattern 4

Again, she draws the outlines, which increases the illusion of three-dimensional textures in the cloth.

step13 Clothes 1

Ayumi draws the shadow of the lace, increasing the 3-D effect. She overlays brown, blue, and red on the dress, drawing it like a shadowgraph. She says, "I first draw shadows on the edges, while leaving the outline. This is possible with acrylic colors, because they are water resistant."

step14 Clothes 2

To paint the silk hat, she creates a color between khaki and gray using yellow, blue, red, and white, while adding a silky quality and gloss.

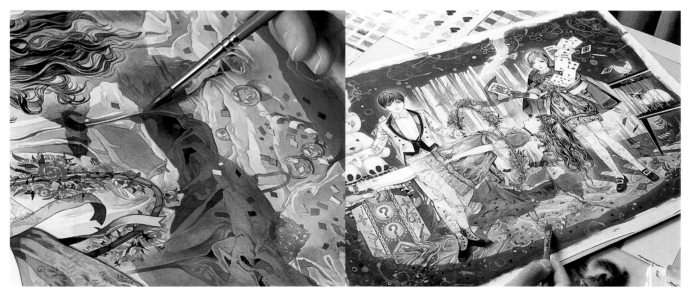

step15 Fabric 1

She first grounds the picture with maroon, then adjusts the color of the fabric. She repeats the following step: Overlay water entirely with vermilion and pure red, paint on the red, then brush off with water.

step16 Fabric 2

The picture result is gorgeous and sensual due to the addition of velvety red. Ayumi says, "I played with the strange texture on the edges."

Ayumi Kasai
笠井あゆみ

Paint Collection

Top left: Winsor & Newton Watercolor Medium set
Top right: Faber-Castell Polychromos pencils, 120-color set
Bottom left: Set boxes of acrylic pencils—Holbein Liquitex
Bottom right: Winsor & Newton Watercolor Pans (96 colors)

Ayumi also used other painting materials, such as Holbein Transparent Watercolor, Copic colored inks, and Mac.

Paints and Materials Used in this Work

Ayumi mainly used Winsor & Newton watercolors for this work, and Fabriano Classico 5 for the paper. She drew on B3 paper, first tracing a line drawing with pencils, then pasting the paper with water on a piece of board. She used a Pentel #0 Neo-Sable brush and other kinds made for acrylic painting.

Interview with Ayumi Kasai

Q: Your pictures are unique, and nobody can copy them. They have a particular sense of paint transformation. When you interpret an image you captured with your eyes, you transform it into a certain shape and transfer it onto paper. Is there a reason why you use fluorescent paints?

Ayumi: If I had learned to use fluorescent paints technically, I would not have painted in such a way. I prefer sober colors, so I want to paint with only one color, but that would not be appropriate for a cover, so I had to choose bright colors.

Q: You used to use yellow-green frequently, too.

A: That color doesn't come out well in print media. I didn't really like that color. In the past, I forced myself to use fluorescent colors because I wanted to make my pictures catch people's attention. In fact, I like sepia and I've been using it recently. I have always liked the retrospective atmosphere. But my painting style changes easily. I always expect that I should be able to draw better pictures. If you have been engaged in my work for a long time, you need to have a goal in your career. Before, I just had fun drawing. But it's a different story when you do it as your job. Sometimes you are not emotionally stable and feel depressed, but you have to finish before the deadline, no matter how unwell you feel. It takes effort to maintain your motivation constantly. If you're emotionally down, your hands don't move.

Q: You also used to use clear-cut black.

A: Yes, I feel I am better at monochromatic painting than color painting. I like the world of black and white. One time, a friend told me, "Clear lines are a characteristic of your painting, so I think that's your strong point," and I felt the same way. However, a monochromatic picture and a color picture are drawn differently, and if you draw lines too clearly for a color painting, the lines will dim the colors unless the colors are strong enough. Strong colors do not suit my style and I try not to draw with them much.

These days, I draw lines with sepia or a pencil, and I think these pictures are close to my favorite effect and to what I want to draw. There's another reason why I weaken the outlines—the lines always become thick when overlaying colors on pen drawings. The color does not blot because I use waterproof paints, but I think it's really due to the paint particles. Thick lines make a picture look dowdy, and I think fine pencil lines are more effective. A pencil drawing goes well with a blurry painting.

I have maintained the same wish for many years—to become a better painter, and I feel the desire is stronger now. Recently, I bought a basic manual for watercolor painting. As I read it, I was surprised to find many things I had overlooked, although I knew them by heart.

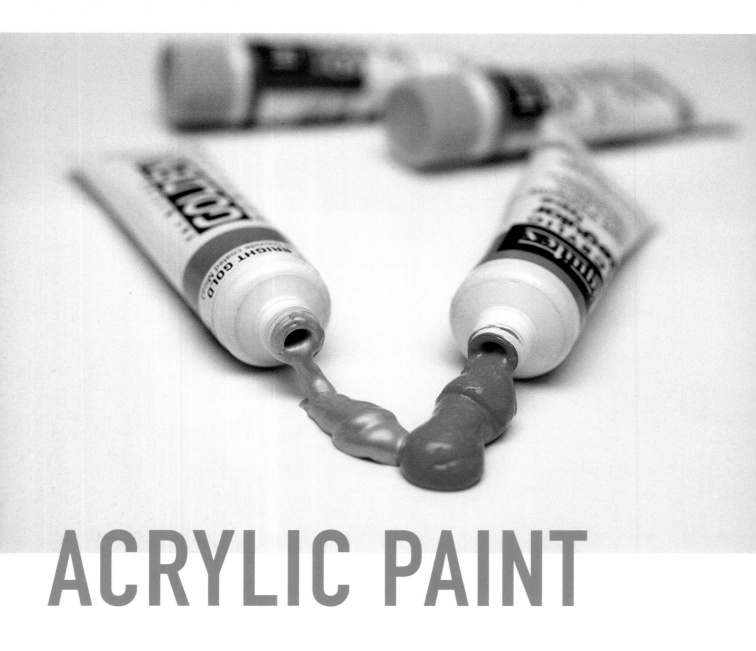

ACRYLIC PAINT

What is Acrylic Paint?

Acrylic paint is one of the last paint media to be released in the twentieth century. It can be applied to any kind of material and is suitable for both thin and thick coats. It is a universal paint medium made from acrylic resin that enables you to produce various effects.

The opaque type is called gouache. You can choose which type is best suifed to your own drawing.

Characteristics of Acrylic Paint

The most prominent characteristic of acrylic paint is its water resistance after the paint dries, despite being water soluble like

watercolors. This feature also makes the surface of your painting durable. When the paint is completely dry, it does not become cloudy, even if you overlay other colors. An opaque acrylic does not show through underlying colors.

Acrylic paint dries more quickly than watercolor, so you should use a wet palette or supplement moisture frequently with a sprayer. You need to be extra careful when painting, especially in dry weather.

With this type of paint, colors come out bright and do not become cloudy when mixed. Some manufacturers have introduced metallic colors, such as gold and silver, which you may also want to try.

Acrylic Paint Techniques

For use as a watercolor, acrylic paint is laid over repeatedly with a lot of water or it can be applied with a little water like a thick coat of oil paint. When working on a thick coat, you can use a painting knife to create a dynamic texture. It can also be used with an airbrush; be sure to adjust the volume of water to produce the desired result.

The range of effects you can create with this paint further expands if you use different types of media, such as gesso for groundwork, a gel medium that has strong adhesiveness and transparency, a modeling medium that is sticky and can be heaped up by mixing it with acrylic paint, and others. Another

Liquitex Artist Acrylic

The colors have a glossy and transparent look, and hardly discolor or change. They can be used right out of the tube. They come in two types: heavy body, with moderate durability; and soft body, a permanent type that goes on smooth.

Heavy Body Artist Colors
105 colors, 2 oz. (59 ml), 4.65 oz. (137 ml), 7 oz. (207 ml)
88 colors, 2 oz. (59 ml) tubes

Soft Body Artist Colors
88 colors, 2 oz. (59 ml) tubes

Assorted packages are also available.

http://www.liquitex.com/default2.cfm

Liquitex Acrylic Gouache

Unlike other Liquitex colors, which are transparent and glossy, Liquitex gouache is opaque and matte. Its strong colors are very attractive. As an opaque paint, it does not show through underlying colors.

74 colors, .7 oz. (20 ml)

http://www.liquitex.com/default2.cfm

Golden Acrylics

Golden acrylic paint is made from only one type of pigment, so the colors are bright and sharp. It does not become cloudy, even if several colors are mixed. It spreads well and can be used for various purposes.

98 colors, 2 oz. (60 ml), 5 oz. (150 ml) tubes

Turner Colour Works
http://www.turner.co.jp/english/index.html

Turner Acryl Gouache

This type of gouache dries quickly and is water resistant, thus, several colors can be overlaid without blotting. Its finish looks like velvet without gloss, and its colors are characteristically bright.

195 colors, .7 oz. (20 ml) tubes

Turner Colour Works
http://www.turner.co.jp/english/index.html

option: a medium with particles that highlight a different texture and enhance the range of acrylic effects. Many people are attracted to this paint once they know how fun it is to use.

Some manufacturers sell these in small packages of tiny bottles. They are intended for various uses.

Pointers for Using Acrylic Paint

One disadvantage of using acrylic paint is that it dries quickly. It is also difficult to wash off the palette, so you should use a ceramic plate or a disposable paper palette. You can also use a wet palette, which comes with a wet sponge that delays the drying.

It is difficult to wash brushes with acrylic paint on them. Nylon brushes, which are used exclusively for acrylic paint, last relatively longer than normal brushes. Brushes should be washed thoroughly after use. A special paint remover may be helpful, but brushes should be treated carefully since they can be damaged easily.

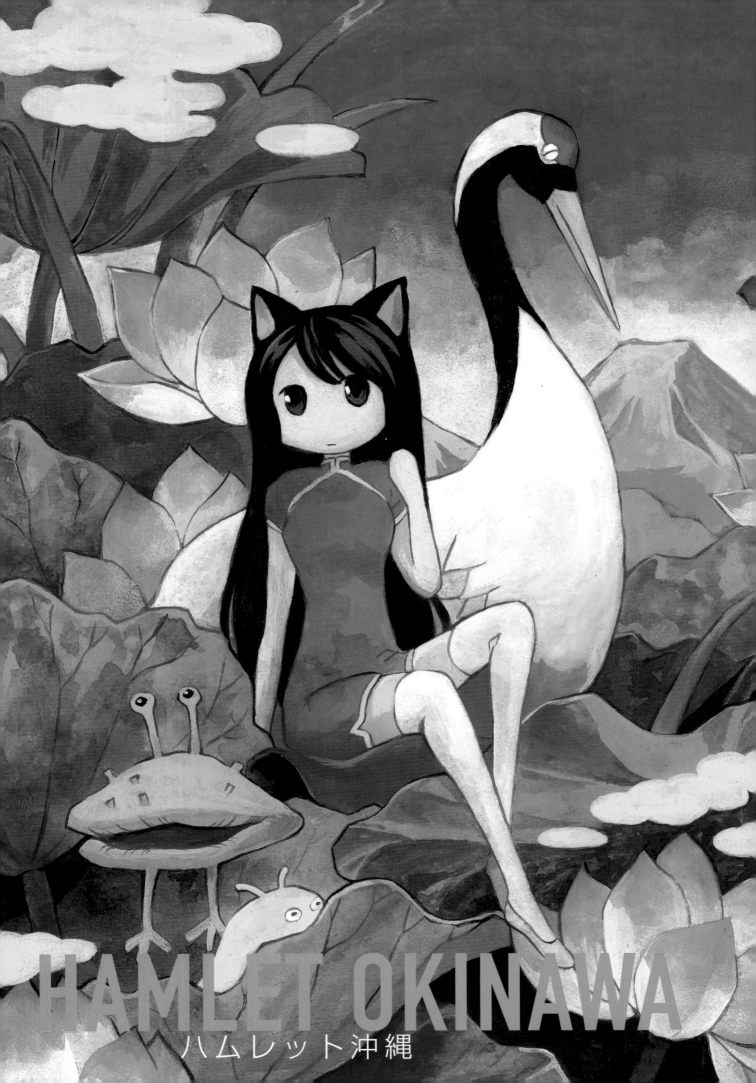

HAMLET OKINAWA
ハムレット沖縄

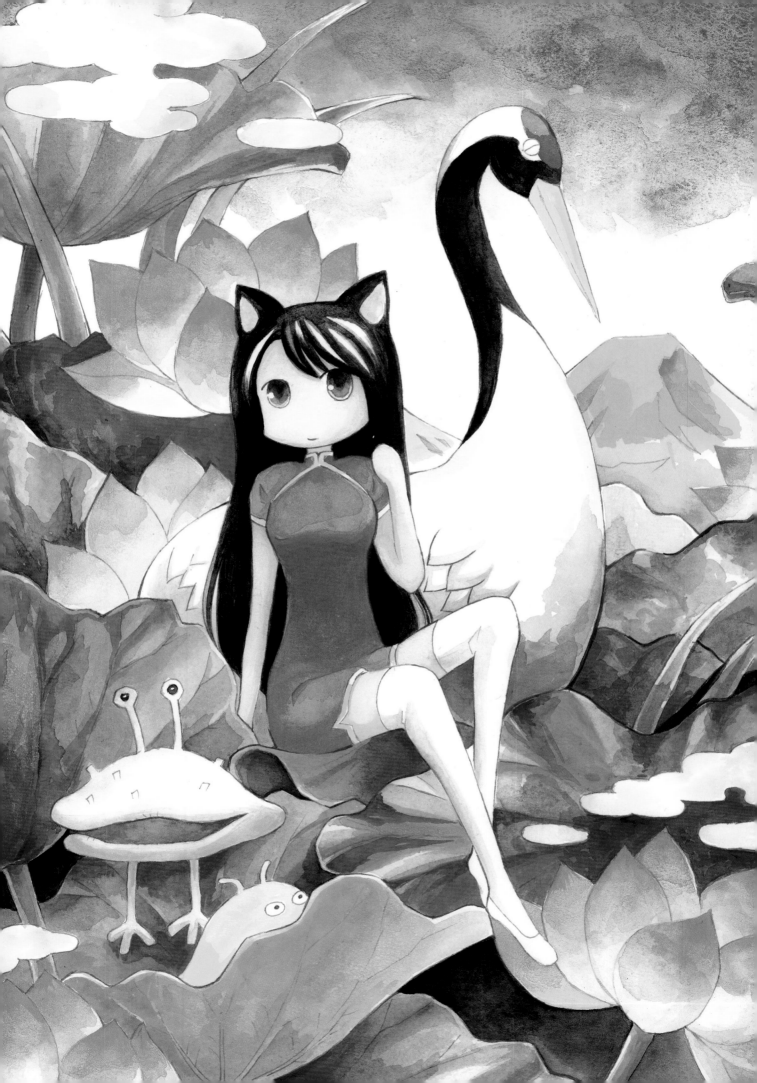

HAMLET OKINAWA
ハムレット沖縄

Background Sketch

Before starting to color, Hamlet creates a background sketch to determine the overall picture tonality. He uses Liquitex acrylic paint, but Liquitex becomes opaque when it dries, so he starts with a thick but translucent coating. He also creates special textures with gesso. Making mistakes along the way is not a problem as long as the various colors are applied with full, powerful strokes.

step1

First, paint the background, applying gesso over the lines. Paint colors completely to cover the ground of the entire drawing.

step2

Dilute Indo-orange red with water, and apply it thickly to the painting. Leave uncolored the skin and other parts that will be painted with light tones. Your drawing does not have to be precise.

Painting the Skin

Liquitex has a very low level of transparency, but when a very bright or light color is laid over a strong color, such as black, the underlying color passes through the applied color. Apply light over dark colors—in this order. Do not worry if the color extends beyond the lines.

Painting the Eyes and Hair

Color the hair and eyes. You may start painting the entire picture, but it is better to start from the characters and then to overlay the colors. Paint the small parts carefully with a line-drawing brush because dark colors can appear quite strong.

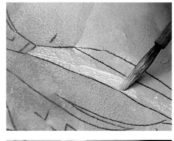

step4

Color the arms and eyes. You may add some color in the shaded areas while checking the overall picture balance. Overlay more colors when the underlying ones dry.

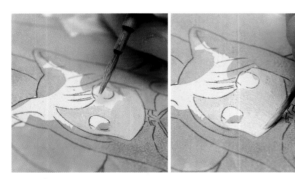

step3

Paint the basic tone of the skin color. If the skin is light, it is fine to extend beyond the lines. Then, overlay the colors in the skin's shaded areas.

1

Hamlet Okinawa is a well-known artist from the Illust-Masters (Illustration Masters) exhibit. He specializes in a coloring technique that uses Liquitex acrylic paint to achieve a thick coating.

step5

For the hair, apply dark colors over the background. Work very carefully when painting with dark colors; these should *not* extend beyond the lines.

step6

Overlay the dark colors and add some highlights. Hamlet uses gesso because its matte colors produce a good effect and give a 3-D image.

Thick Coating

Liquitex is especially good for a thick coating, which is important for creating a unified impression of the picture tone as a whole or for maintaining deep colors. Conceive of a rough idea for the color arrangement and the entire picture balance, then paint repeatedly with broad strokes.

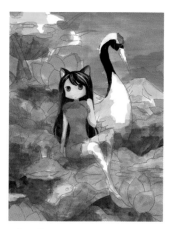

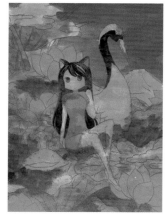

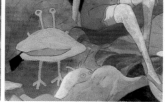

step9

When the paint is dry, apply more colors repeatedly. Pay attention to the characters and other motifs, as well as the dark and light places.

step7

Consider using single colors, then apply them with broad strokes. Lay the brown colors roughly over the more colorful shades.

step8

To bring out an integrated picture tone, Hamlet overlays all with red Liquitex.

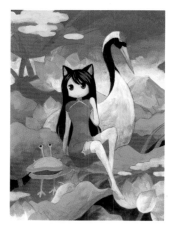

step10

Consider the picture balance by placing the character in the center and applying more colors carefully, as needed.

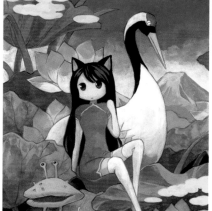

Completion

The painting is completed and fully expressed with the use of Liquitex. Many colors are laid over each other, and, as a whole, they express a deep tonality.

HAMLET OKINAWA
ハムレット沖縄

Painting the Skin

First, paint the basic skin color. For a thin coating, which requires a lot of water, the paint can be used as a normal watercolor. Apply water, then brush on the colors softly before they dry. This step can produce a beautiful blotting effect.

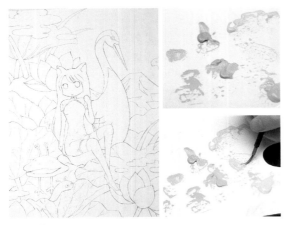

step1

Make a draft with a brown pen and prepare the skin color. Mix various colors to create a deep color.

step2

A thin coating requires good command of water usage. First, apply water, then overlay the skin color. Paint the shades of the skin at the same time.

step3

To work on the skin of the arms and other body parts, first apply water and the basic color, then overlay the shades of the skin.

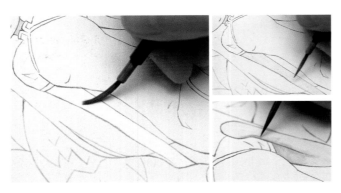

Painting the Eyes and Hair

The eyes and hair are the principal components of the face. These are painted with dark colors so the face can leave a stronger impression than any other part of the painting. First paint light, then dark colors in order to obtain a strong image. Draw carefully, because your brushstrokes reflect on the painting as a whole.

step4

First apply water, then add colors softly to paint the pupils. Add darker colors gradually to express the curve of the eyes and shades.

2 This section illustrates the use of a thin coat, which can be done with a soft Liquitex acrylic paint.

step5

Paint the hair carefully so that the color does not extend beyond the lines. Turn the paper around to make strokes to express the wave of the hair. Paint from light to dark colors.

Overlaying Colors

Unlike a thick coat, a thin coat is almost identical to watercolors. It has to be painted on as you simultaneously check the overall picture balance, just as you would for a thick coat. However, it needs to be painted more carefully.

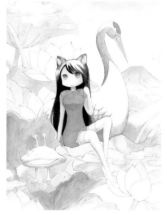

step8

After you finish applying colors roughly, check the entire painting and overlay colors further to draw the figure in the center.

step6

Apply unique colors onto the rough outlines of the motifs. Apply mainly light colors as you check the picture balance.

step7

Apply colors onto the shades so the picture looks 3-D. Try to maintain good proportion among the picture elements as you check the tonal balance.

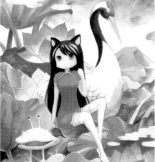
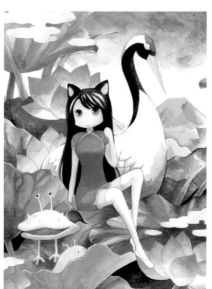

step9

Apply dark colors, and paint the bright colors onto the lotus flowers and other elements while ending with a finishing touch.

Completion

When the painting is complete, it will have a transparent quality. But the bright colors will look very much like watercolors, giving a generally gorgeous effect.

Computer Graphics

What are Computer Graphics?

The term *computer graphics* refers to the creation and/or manipulation of images with a computer and basic tools, such as software applications and a tablet. The cost of materials is the highest among all available painting methods. However, there are a lot of advantages in using this digital method, and many professionals have been switching to it. But you have to remember that computer graphics do not transform you instantly into a skilled painter; you have to acquire the skills to make good use of the technology.

Characteristics of Computer Graphics

Software applications enable you to use various techniques that used to be difficult to perform with traditional analog methods. These techniques include filtering effects, color correction, inversion, distortion, and others. Nowadays, the functions of software have improved immensely, so much that it is possible to paint or draw almost in the same way as one would manually. In addition, saving digital data enables you to store the original drawing without loss or deterioration of quality, and this allows you to send work digitally to another person without worrying about damage.

It is also possible to redo a drawing repeatedly with computer graphics, facilitating many trials with various colors, so that you can produce dynamic results. On the other hand, it is difficult to reproduce accidental blotting or unevenness, which are possible when doing manual drawing. With computer graphics, you need to adopt textures or effective features of traditional analog methods.

Techniques of Computer Graphics

The versatile software Photoshop was originally created for the purpose of making corrections to photographs. It is the best tool for color correction, tonal conversion, image processing, resolution change, and others. If you are seriously thinking about using computer graphics, Photoshop would be the best software to start with. Painter users turn to Photoshop for fine adjustment after finishing a drawing to a certain

Adobe Photoshop CS3

Photoshop is a well-known software for major digital image editing. The latest version of Photoshop CS3 (and Photoshop CS3 Extended) has efficient functions for image making, editing, and file processing, and also enables easy customization of work spaces.

There is no predetermined solution for coloring methods using Photoshop. Coloring methods improve day by day, as computer functions do, and Photoshop can also include traditional methods. The brush function of Photoshop has improved far beyond its past versions; you can try to develop your own color and coloring method. A digital tool is a painting material by itself, and its effective use depends on the the skills of the artist.

Another type of software called Photoshop Elements (Version 4.0 for Macintosh, Version 6.0 for Windows) is a functionally limited version of Photoshop. There is also other cheaper software with almost the same functions as Photoshop, although their interfaces and functions are slightly different.

Hardware Requirements

Windows

Intel Pentium 4, Intel Centrino, Intel Xeon, or Intel Core Duo (or compatible) processor
Microsoft Windows XP with Service Pack 2 or Windows Vista Home Premium, Business, Ultimate, or Enterprise (certified for 32-bit editions)
512MB of RAM
64MB of video RAM
1GB of available hard-disk space
Internet access

Macintosh

PowerPC G4 or G5, or a Mac Pro with an Intel multicore processor
Mac OS X v.10.4.8
512MB of RAM
64MB of video RAM
2GB of available hard-disk space

Photoshop of Adobe Systems Incorporated
http://www.adobe.com/

Painter

Painter is the software that specializes in drawing pictures. It has many functions that enable reproduction of analog results. Thus, it is rather difficult to utilize fully if you are not skilled enough to draw a good picture. You may want to try using various kinds of brushes that come with the software.

A new version, Painter X, is equipped with brushes that can reproduce various types of techniques and media, such as acrylic, airbrush, artist oil, calligraphy, chalk, Conté, charcoal, oil pastel, felt pen, gouache (opaque watercolor), oil paint, pencil, sponge, and more. Each brush is equipped with functions that make fine adjustments, so you can paint your pictures as if you were using real materials that can produce unexpected results.

Hardware Requirements

Windows

Windows VistaTM, Windows XP or Windows 2000
Pentium III, 700 MHz or greater
256 MB of RAM (512 MB recommended)
360 MB hard disk space

Macintosh

Mac OS X (version 10.3.9 or higher)
Power PC G4, Power PC G5 or Mac Pro with an Intel multicore processor
256 MB of RAM (512 MB recommended)
280 MB Hard disk space

Painter of Corel Corporation
http://www.corel.com/

point. Photoshop is also useful for enhancing your range of techniques using layers and alpha channels.

The old Version 7.0 has an excellent brush function that responds to the need to customize various expressions. Photoshop can scan your original pictures to add fine corrections.

Painter is a software that specializes in drawing pictures. It assists your painting with a natural touch, as if you were drawing with your own hands, using the styles of oil painting, watercolors, pastels, and other media. With Painter, it is also possible to choose paper textures that produce a color effect similar to the way your manual drawing would appear on your computer screen.

Risks in Using Computer Graphics

One risk in using computer computer graphics is the high cost of purchasing a full set of tools. There is free or less expensive painting software, but you should be well prepared to buy well-known software, such as Photoshop and Painter. Certain types of software may also not run well on your computer, depending on its capacity. You will need adequate memory in your computer and substantial knowledge of computers and computer graphics software to take advantage of their potential.

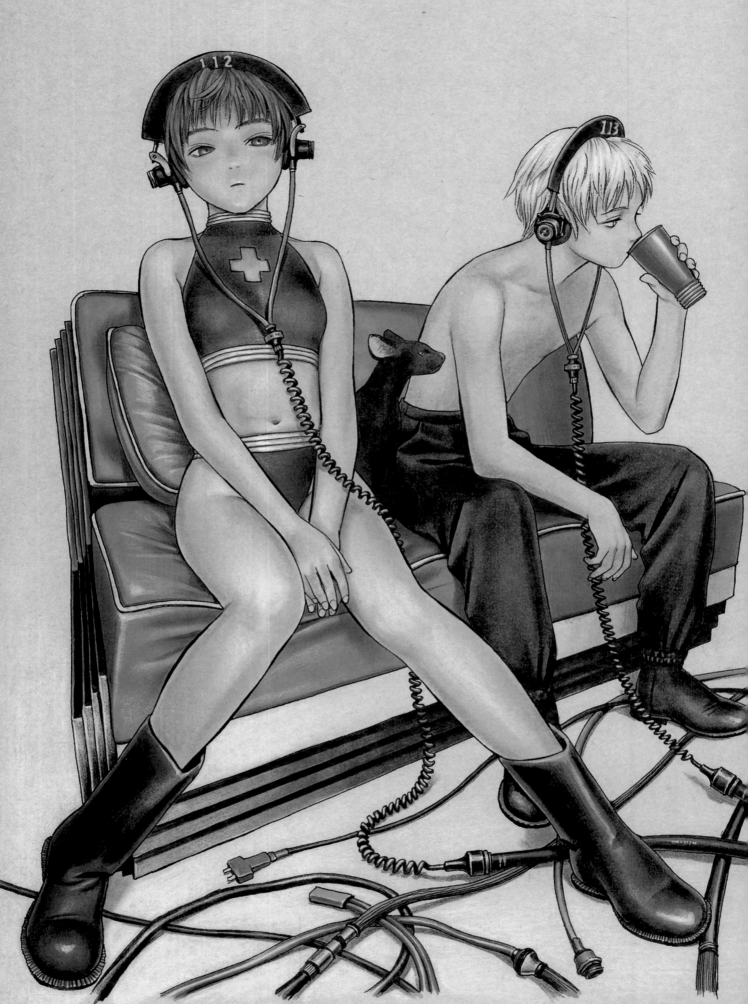

"Kairakuten" (October, 1996)

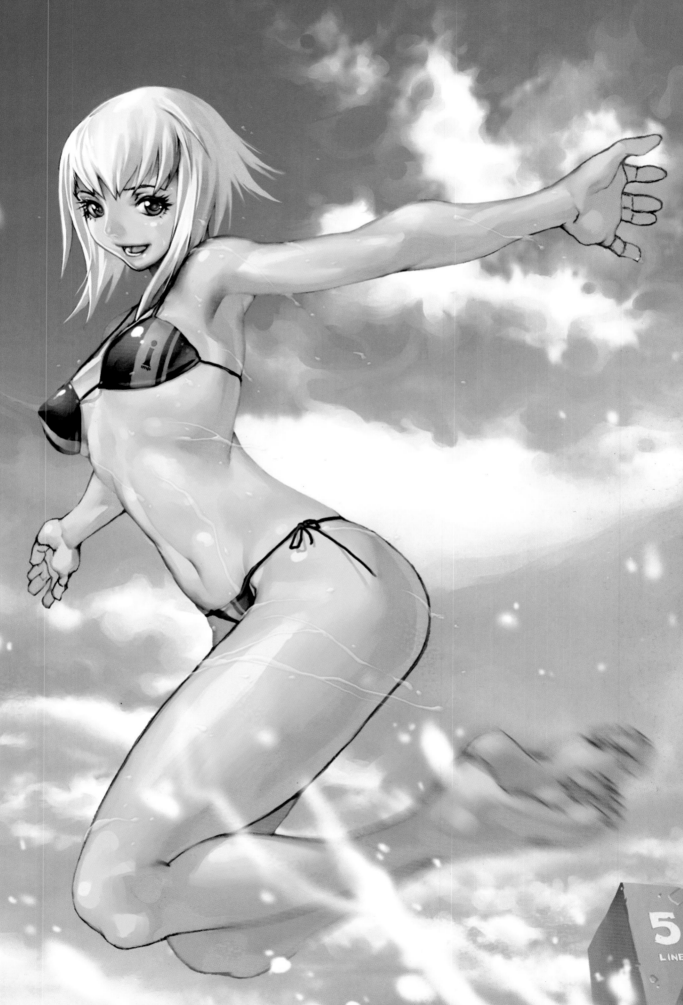

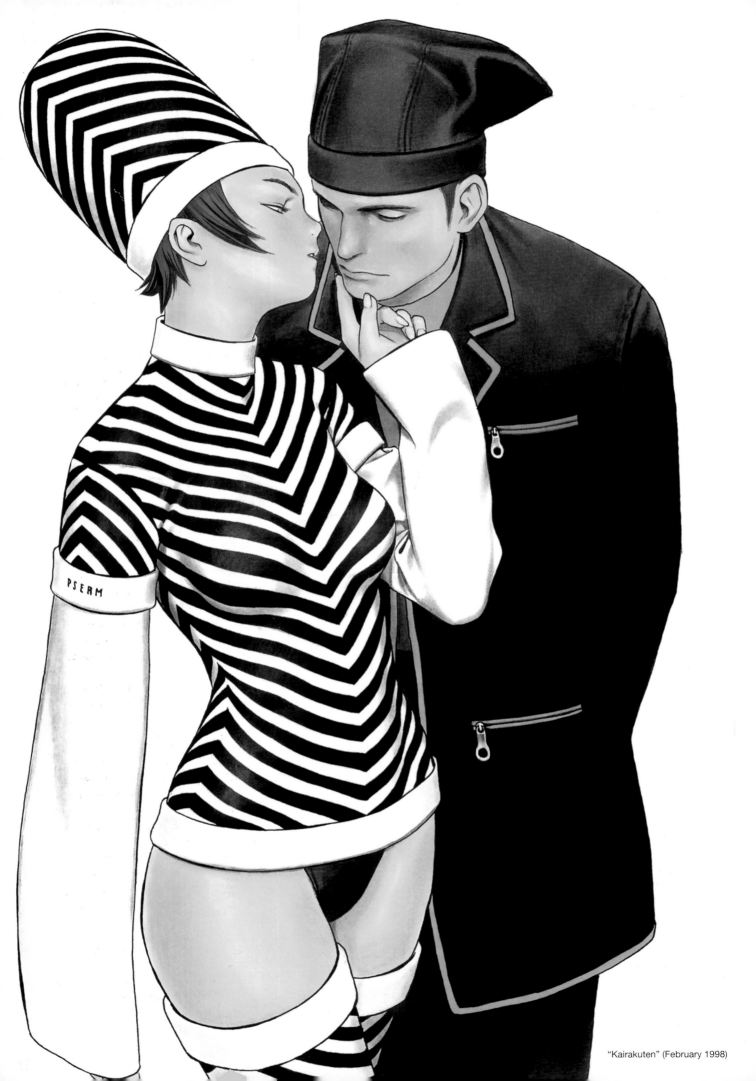

"Kairakuten" (February 1998)

Renji Murata and Kim Hyung-Tae

村田蓮爾

キム・ヒョンテ

Renji Murata
Born in 1968 in Osaka Prefecture, Renji Murata became popular after designing characters for "Power Instinct" and "Groove on Fight." Since then, he has been engaged actively in a wide range of creative media, such as the video game "Wachen Roder," animations "Blue Submarine No. 6" and "Last Exile," the "Fa Rengi Murata's Collection Exhibition," and the publication "Robot," which he directed as editor in chief.

Kim Hyung-Tae
Born in 1978 in Seoul, South Korea, Kim Hyung-Tae started working for the video game company SOFTMAX in 1998, then became a character designer for "The War of Genesis 3" and "The War of Genesis 3, Part 2." He was involved with the entire production of the character design and 3-D polygon characters for "Magna Carta," which was also released in Japan. His picture collection book is published by Enterbrain Inc.

Kim Hyung-Tae (K): I have known about Renji's pictures for a long time, but I had limited opportunities to see them, although I really like them a lot. In the past, we didn't have the Internet, and when I heard that his picture was published in a magazine, I ran around town to all the bookstores to get it.

Editor (E): It seems that there are many Korean writers who have been influenced by Renji Murata. If I ask them who their favorite writer is, they always mention Renji, don't you think?

Renji Murata (M): I wonder why.

K: Some Korean game magazines pick up Japanese games. I think Renji's picture was first picked up in one of them. But, such magazines had little information. I remember seeing Renji's clips and often exchanged information with other illustrators who wanted to know who he was. I guess there are many people who have been influenced by Renji, Capcom's designers, and Katsuya Terada.

M: Are most of them game illustrators?

K: I think so. I noticed that many characters built especially for fighting games were well established.

M: Weren't a lot of Japanese mangas imported in the past? What do you respect about Japanese magazines and mangas?

K: Well, I saw many people's illustrations, including Renji's pictures. But the use of colors made the biggest impact on me, and I became greatly influenced by that. Also, PCs and the Internet started to be widely used and I had more chances to do research on colors via the Internet, so I did various experiments and this is where I am now.

Frankly, I originally wanted to become a comic book artist. But, in South Korea, many people read Japanese mangas instead of Korean comic books. It is more profitable to buy Japanese copyrights and sell the books rather than to have Korean artists write a comic and give them a manuscript fee.

M: There is no Korean manga magazine available, is that right?

K: There are some, but they are not really active in the industry. The market is not well developed and manga artists switch to the game industry instead. There is not enough room for the market to grow, and that's the same situation for manga. Animations are brought in from Japan to China and South Korea, and many people are subcontractors.

M: There are good illustrators for original pictures, and I feel some of them are actually better than Japanese illustrators.

K: I think so, too. But, the market is not well developed because they have been working as subcontractors for a long time. There is an adequate number of good illustrators, but they have fewer chances to succeed, even if they have done a good job. Therefore, in this current situation, artists who draw pictures have only one direction, which is to go to a game company.

M: Even if you're a highly skilled illustrator and want to become a manga artist, you don't have a place to present what you've produced.

K: That's right. Some users play only

Renji Murata and
Kim Hyung-Tae

村田蓮爾

キム・ヒョンテ

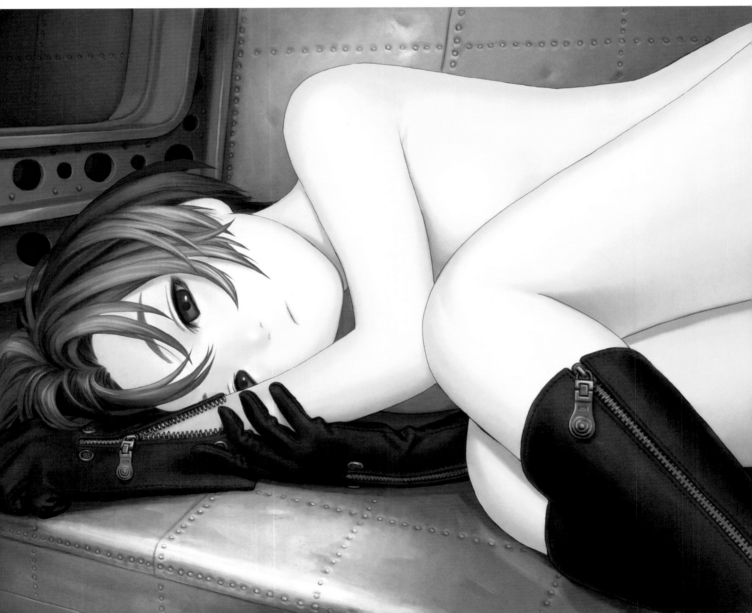

"robot," Vol. 1

Internet RPGs even if they play video games, and some watch Disney movies or only Japanese animations. The users are divided into these categories and the size of each market is becoming smaller and smaller. In such an environment, South Korea has been successful in developing its original Internet RPGs, and this has been the only category that has been growing rapidly.

Even if you study hard in school and develop technical skills, there are only a few places that offer you a job, so creators end up getting a job at a game company. There are also many people who study aboard, for instance in Japan or in the U.S., and eventually live there.

However, I think creators are also responsible for this biased culture. Nowadays, they try to widen and diversify their area of activity.

M: I guess more Korean users would want to see their work if there were more artists with your mentality to attain such diversity. Japan is special in that respect. We have a history of manga and animation popularity spanning fifty to sixty years. South Korea will change in the same way, I'm sure.

K: I believe so, but I feel that the present trend is imbalanced because all of a sudden, everything seems to be developing rapidly.

M: Younger generations are not catching up with the technology and trends?

K: Right. The current situation shows a promising future, so I carry out my tasks thinking that if we

believe it, we can do it, and younger generations will follow us.

I had a chance to publish a picture collection, but I guess a personal picture collection or a collection of game illustrations is not really popular yet in Korea. However, I started to feel that the market is expanding gradually as a result of our activities.

E: Renji, you are often invited to anime and other events in the United States and in Europe. Now, after seeing the animation and manga markets over there, how do you feel about the fact that current Japanese works are appreciated in the rest of the world?

M: I haven't thought about it deeply, but I think such a tendency will increasingly continue year after year, and the fervor will be enormous. In Japan, the main information medium is still paper, but in the case of animations, a program broadcast tonight in Japan can be shown the next morning in the United States. In that sense, animations are easily understood by people abroad.

However, if you ask viewers whether they have understood the contents completely, they do not really comprehend them well. There are manners or rules that the Japanese normally see and understand. For example, the symbol of sweat is not well understood by people abroad.

K: In South Korea, many people look at Japanese works, and Korean mangas have similar symbols, so it's not difficult to understand the symbol of sweat and other things.

But there is one problem. There are

obsessed fans who like Japanese animations so much that they cannot communicate with other people. I understand Japanese animation has a long history. New animations are rushing into the Korean anime culture, and old animations are no longer revived. So, the gap between recent viewers and those who have been fans of animation for a long time is becoming greater. As a consequence, the world of animation is increasingly becoming a form of entertainment for the most ardent fans.

Japanese animation has a long history, and this may be the cause of a large gap between generations. I see only the latest work, and I feel everything is overwritten in them.

M: I have a desire to create new forms in Japan. I already have a concrete idea about animation style. When you want to break a trend, you pick up special features, like lovely anime characters or other graphic aspects to make a change, but when you show them abroad, people from other cultures may feel odd about the changes.

I should be able to accept the changes immediately without any doubt because, living in Japan, I can feel them. However, when I look at an American comic, for example, Superman shows up with red briefs. I think red briefs look funny; they are not cool. But maybe American people think they are cool and accept them without doubt; they do, don't they? I think it's because they have a long history of Superman. If people in different countries saw Japan's Kamen Rider and Ultraman, how would they feel?

Renji Murata and Kim Hyung-Tae

村田蓮爾

キム・ヒョンテ

K: In South Korea, we call him Grasshopper Man.

M: Grasshopper? And, do they wonder why he's a rider with a mask?

K: He's also called a Masked Rider, right?

M: People in other countries may not understand that. For us, Kamen Rider has been with us since a long time ago. Now he doesn't even have eyes! Well, you may be talking aboutt the Kamen Rider series if you talk about a rider.

K: Kamen Rider is changing and so is Superman in the Hollywood movies. X-Men characters are also changing from their original shapes so they can be more appealing to the general public. By the same token, Japanese culture needs to change itself to be understood so that everyone in the world can empathize with it. I sometimes think that Japan should be responsible for making such a change.

M: I feel the same way.

K: Japanese anime has a long history and an enormous energy. That's why I have great expectations for it. If you put the good aspects of old animation in the contemporary stream, I think more people could have more compassion for Japanese anime.

M: Of course, some Japanese create animation that generates such compassion, and there have been many works of animation that were

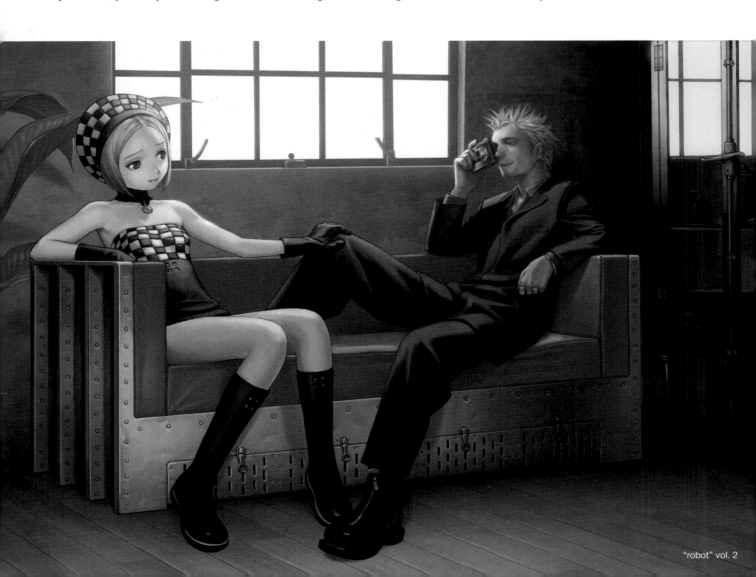

made easily with an investment of only about 50 million yen.

In Japan, there are about 150 animations aired each week on television, but it's a tough question to ask me how many of them have meaningful content and have fulfilled what they were expected to do. In the case of film animation, not TV, creators work together for one or two years, and they can produce successful results. But, I think it is difficult to achieve the same thing for TV animation. However, there are some works that have oddly interesting subjects and scripts. For example, what do you think about Ghibli's animations?

K: I consider Ghibli's animation work a Japanese animation, but I don't see it so much as "real" Japanese animation as it is simply Ghibli's work. Looking at it this way, the power of animation seems to be dispersed by category, but I think it would be better if animation were

considered one entity. I think it's the same thing for mangas and games, not only for animation. We need to have conversations with the world so people outside can feel a connection with Japanese works, or Japanese creators should learn to share our compassion so that other artists from various countries can participate more spiritually in the industry. In this way, the animation market can expand more, and creators from Japan and those from other countries may be able to directly communicate with each other.

Japan flourishes alongside various cultures, so I think it is responsible for propagating such activities, and I really hope this will happen soon for the Japanese people.

M: I understand.

E: In Japan, many past creators emerged from game producers. For example, Renji also used to work at a game company, and there were

creators who came from Capcom and other such companies. The present Korean game market is also growing tremendously, and many creators are entering the game sector. What kind of message are they trying to send us?

K: In the current situation in Korea, within the genre of games there are other subgenres and each is directed at different aspects. Many creators have moved to Japan and the United States as part of this. I've recently seen some creators who have established their own particular style—an American style that is similar to American comics.

I think from now on, the roles of these artists will become more important. They work in the animation and film industries, and I hope their activities will become part of one culture.

I published my picture collection as part of this effort. I did it in Japan

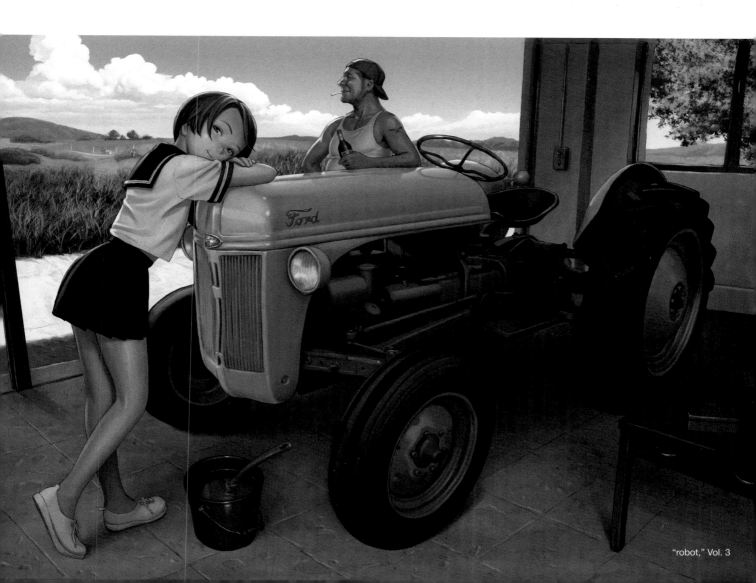

Renji Murata and Kim Hyung-Tae
村田蓮爾
キム・ヒョンテ

because there was no precedent in South Korea. I was worried at that time because it was my first time to work on it.

M: Don't worry about it. I heard it's selling a lot.

E: I took a look at your picture collection. There is no doubt that you are a good painter, but there should be a point that matches the taste of the Japanese people. I believe their taste has matched your illustration.

I think your pictures include expressions and costumes that emote feelings that anyone understands. They do not make you feel any differences between Japan and other countries, but rather express compassion for the Japanese people. I am able to find the points in your illustrations where you give your best effort, or the aspects that you want to draw the most.

K: I have personally been influenced by the Japanese culture, and there are some parts that I drew with my own interpretation, so I think that's where you feel empathy. It was created naturally though.

These days, there are many cultures coming into South Korea from different countries, such as the U.S. and Japan, so I always try to learn something from them. But my top priority now is really to take in anything that makes my illustrations more beautiful.

However, I feel that many recent creators try to succeed with their artistic sense. Since I don't have such artistic sense, I try to manage everything with hard work and attention to details.

"Kairakuten" (August 1999)

M: That should be enough.

K: When I'm stuck with such concerns, I look at your beautiful pictures and that encourages me to do a better job.

M: Not a problem. You are already better than me. Was there any antecedent for such types of illustration, Hyung-Tae? My first impression about your works is that they are very familiar to the

Japanese people. There is nothing about them that makes you feel odd when you see them in Japan, don't you think?

We didn't know about Korean culture before today. I wonder why suddenly an illustrator from Korea appeared who could draw like a Japanese artist. Well, actually, he is a lot better than many Japanese artists, and his drawing could lead many Japanese art scenes.

I think that we have been living in Japan seeing Japanese animation and mangas that influence us, and we haven't necessarily been making our own original characters with our own symbols.

On the other hand, although I'm not sure how much of our culture influences creators from other countries, other types of illustrations have emerged apparently in Japan, and I wonder how these illustrations could also appear in South Korea. It was like a surprise to me.

Hyung-Tae has a special talent and a sensibility similar to that of the Japanese people. As mentioned earlier, I don't think you express the same context as Japanese people, but to me, it's a great mystery how you could draw in that manner.

Katsuya Terada, the people at Capcom and I have always had a motto, which we add various elements to. If I see Katsuya's illustration, I can read between the lines, even if I didn't know the plot.

Mimicking an illustration can become totally superficial, and although you may be able to copy Katsuya's illustration, all other elements will be revealed when you draw another character with a different appearance.

If Americans draw like Japanese animation, they can copy it. But their drawing will reveal the taste of an American comic, with a very heavy look. This is because they draw from an American basis. But, in the case of South Korea, I don't feel any oddness in Hyung-Tae's drawing, for example, that gives a heavy look to the animation. Even if

you draw something else, your drawing comes with a degree of completion that can be accepted in Japan with no problem. This puzzles me. Maybe, Hyung-Tae has a basic talent for translating various cultural aspects.

K: South Korea is a neighboring country of Japan, where a lot of cultural aspects have come down from your country since a long time ago. So, I have tried to accept what

I didn't have to refuse, and to draw honestly. I guess that's how I was able to establish such a style.

M: So, you've always had the talent.

E: With that in mind, you show excellent taste in ornaments and clothes and these elements have identity. Where does the imagination come from? Everyone wonders about that.

"Kairakuten" (September 2000)

Renji Murata and
Kim Hyung-Tae

村田蓮爾

キム・ヒョンテ

"Kairakuten" (March 2001)

"Kairakuten" (April 1998)

M: Old-fashioned ten-year-old accessories and clothes are totally acceptable in Japan.

K: Korea and Japan are not so far from each other culturally, compared to China and the United States. I think this is due to the fact that we were easily influenced by each other and are able to share our cultures.

M: What surprised me and my illustrator friends about Hyung-Tae's illustrations was the unique touches of a painter. In Japan, we usually look at the same thing from the same country, so we tend to say that certain places should be drawn in a certain way, or certain drawings are in fashion or not. But, Hyung-Tae's drawings are different; I felt that it was possible for a Korean to draw in such a way.

K: I don't think that there is much difference between Korea and Japan. When I started the game project "Magna Carta" in 2000, I tried to find some common symbols with which we could share the same passion, and I continued my creative work with that in mind. Then, people started to look at my illustrations with less hesitation, I guess. I hope that I will be able to connect with the world in this manner.

M: I didn't know that there was someone who drew pictures of games to be released in Japan.

E: Hyung-Tae is considered to be the first generation of Korean commercial illustrators. I think he is also the first Korean creator to establish such a position because there had been no one who filled

that role before. How do you feel about being in such a position?

K: My goals up to now have been to come to Japan to have my illustrations looked at and published in Korea so I can establish my own position in my country. But from now on, I would like to share our cultures more with the public. I need to make myself accepted in my own country without any risk, and while the foundation is almost present to allow such a circumstance, I think I will have to create what couldn't be seen before — and, this becomes my sense of originality.

E: Renji, how do you feel when you see someone like Hyung-Tae who expands his field of work in Japan?

M: I truly welcome such a person and I think it's fun to see that this

world is activated by so many people. I feel I can create something interesting if I work with people like Hyung-Tae.

K: Thank you very much. To me, this is my first step in establishing my creative position and I would very much like to do my best not to end this enthusiasm as merely a transient boom.

In the past, I think there was a barrier between different countries. But I believe such a barrier has gone thanks to the Internet. I find Korean creators in Japan and Japanese people alike in different countries. I think that the timing for such interactions has come earlier than I thought.

Renji Murata and Kim Hyung-Tae

村田蓮爾

キム・ヒョンテ

Renji Murata's Publications

"**Robot**" is a well-known full-color comic and art book, featuring Renji Murata as chief editor. Participants in the latest issue, Volume 4, issue are Renji Murata, Hiroyuki Asada, Yoshitoshi Abe, Enomoto, okama, Kouji Ogata, Yusuke Kozaki, SABE, Sanbe Kei, Yumi Tada, Imperial Boy, Shin Nagasawa, fujijun, Shigeki Maeshima, Migi, Suzuhito Yasuda, and Rco Wada.

From "robot" Vol. 4
• Above left: "Splash" by Imperial Boy
• Above right: "Sedouka" by Shin Nagasawa
• Bottom center: "Super SHERPA" by Kouji Ogata
• Bottom right: "Reese" by fujijun

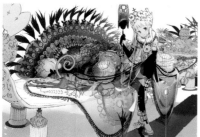

Top, from left:
- "PEZ&D.THUNDER LAND" by Hiroyuki Asada (Vol. 3)
- "Picnic" by Naruko Hanaharu (Vol. 1)
- "Haiiki" by Yoshitoshi Abe (Vol. 3)
- "DRAGON FLY" by Shigeki Maeshima (Vol. 3)

Bottom, from left:
- "Plastic Gothic Dress" by okama (Vol. 3)
- "Hiina" by Kei Toume (Vol. 3)

"robot" Vol. 1 to 3
Published by Wanimagazine
http://www.wani.com/

Kim Hyung-Tae's Publications

Kim Hyung-Tae's popularity is not limited to South Korea alone; his work is also popular in Japan and worldwide. More of his work. and stories behind the illustrations presented in this book, are also published in *Japanese Comickers 2* (Collins Design).

Oxide 2x Picture Collection of Kim Hyung-Tae

Kim Hyung-Tae's first picture collection published in Japan is a compilation of game characters and image illustrations drawn between 1999 and 2004, which also includes his concept art.

- Size: B5
- Published by Enterbrain

Magna Carta

The main character, Calintz, and his companions are caught fighting in a world where the energy form Kan operates under the rule of Carta. This is an RPG that depicts the characters' development.

- Software for PlayStation©2
- Published by Banpresto

©SOFTMAX CO., LTD
©BANPRESTO 2004

Houden Eizou

放電映像

Born in May 1979, Houden debuted in "Dengeki hp" (MediaWorks) in 2003. Since then, he has been in the spotlight as a young illustrator and has drawn illustrations for various works, such as "Asobiniikuyo!" (Media Factory) and "The Fox Spirit of My House" (MediaWorks).

Houden's Debut in Comic Illustrations

— **What made you start a career in comic illustration?**
An editor at MediaWorks found my Web site and e-mailed me, offering me a chance to draw an illustration for "Dengeki hp." That was my first work. Then they saw my final drawing and called me later, saying, "Is it possible for you to draw illustrations for a novel?" These two occasions happened almost at the same time, so I believe they started my career in manga.

— **Have you liked drawing since your childhood?**
It was not like I was aiming only at becoming an illustrator for anime or the manga industry, but I had a vague dream to make my living by drawing pictures, so I learned drawing and went to an art college. Later, I made up my mind to become a manga artist, and as I was wondering how to do it, a guy asked me to start a drawing group with him. My story goes on from there.

— **Were you involved in a drawing group?**
No, actually I was about to. I really wanted to do it, though. At that time, my friends and I formed a group and opened up a Web site; the editor saw the site and called me.

— **You use your name Houden Eizou on the Web site instead of your real name. Why did you name yourself Houden Eizou? Is it a nickname?**

Well, I originally used the words *neon vision* for my e-mail address. I came up with this name randomly while I was reading a magazine, and I was going to translate it into Japanese to use it for the title of my Web site. Neon is a phenomenon of lightwaves (Houden), and vision refers to image (Eizou). Then, I noticed, when I was filling out the application form for a drawing event, that I didn't actually have a pen name. At that time, I thought, Fine, I'll use this, and that was when I wrote my name as Houden Eizou.

Later, when I started to work as a professional illustrator, I didn't have time to think about my real pen name. When I finished an illustration, my colleagues asked me, "What are you going to do about your pen name?" But I couldn't come up with a good one. I thought it might be better to use that than to regret using a funny name that I just think up randomly. This is also a funny name, but many people can remember it.

— **If you could change your name now, what would you call yourself?**
Well, I have no other name at all in mind. I advise everybody to decide on a pen name that can be used forever.

Houden Eizou as Illustrator

— **What painting materials do you use?**
I use a 0.3 mm mechanical pencil, erasers, and Photoshop.

— **Photoshop for everything except for lines? I think that you also use Painter.**
No, I don't use Painter at all.

— **So did you draw pictures digitally before you started your professional career?**
When I was in college, I drew pictures digitally, just a little bit, but after that, I didn't have a computer at home. So, it was not until I bought my own computer that I really started using the digital method.

— **What painting tools were you using? One of your most attractive drawing features is your particular layering technique. And I thought such a layering method cannot be done unless you have experience in using various painting tools.**
I used to work with mainly acrylic paint, but I was not really good at handling paint or analog painting materials, so I'm not confident enough to say that I use them often. I'm not so skilled at layering either. I personally think that you can easily spot works that are painted with Painter, don't you think? I like such pictures, but I don't think I'm skilled for that medium. Anyway, I do my work my own way. My top concern is to find my most efficient method and to paint beautifully.

— **You really like drawing, don't you?**
I prefer showing pictures to others rather than drawing pictures. That motivates me. But there are people who actually like drawing. I always feel I'll never be able to beat those people. To me, it is not a pleasure

From the cover illustration of the second bulletin of "BloodOpera-Entice Us, Red Holy Communion"

BloodOpera

"This game story builds up the scenes gradually and instructs you to draw pictures as precisely as possible. In this drawing, I placed the characters in radial positions and made the light in the background look like a cross. The composition feels compact despite having many characters in it. Tokyo Tower does not look as prominent as it should be."

From the main visual of "BloodOpera-Entice Us, Red Holy Communion"

to just draw every single line; I also have no special feeling towards drawing, but I have complaints while I draw like, "Oh, I have stiff shoulders."

— Do you use Photoshop to draw monochromatic illustrations, too?

Yes, I do use Photoshop for that. I first sketch a picture with a pencil, trace it to make a line drawing, then I scan it for the purpose of coloring. For a line drawing, I don't use the computer so much; I would rather hand-draw as much as possible. When drawing on the computer directly, if the monitor is distorted, everything will become distorted, right? I draw by hand because I'm worried about that. But I am also curious about drawing directly, too.

— When you clean up your line drawing, don't you use ink?

No, I don't. I draw it boldly with a mechanical pencil. I'm not good at inking. Of course, you can't redo when you make mistakes, and I personally don't like that. I think it's a big problem if you are not good at inking, but so far, I haven't had any problems with that.

— What is your work flow like?

The first step is, I scan the hand-drawing, then process it with a computer. In relation to the proportion of my working hours, I spend them completing rough drawings and line drawings. I can finish color-painting in about a day, and I take less time with drawing that's monochromatic. But it takes more time to finish a line drawing— I think too much.

— So, once you start coloring, you work all the way to the end in one sitting?

You can finish coloring while thinking about something else. Once you decide the direction of the light and the color scheme, the rest of the work is simple. Rough drawings require energy or tension. I get stuck for a long time at one place where I'm not satisfied. There are always reasons for not being satisfied. One time, I wasn't satisfied in any way with the rough drawing I had submitted, and I asked the client to give me a chance to redraw it. The compositions and the postures were the same, but I didn't really like the previous drawing.

— Do you have a vision you maintain until the completion of a line drawing?

That's right. I have rough ideas in my mind at that point. I am not really

From the cover illustration of "Asobiniikuyo!" ("Let's Play!"),
Vol. 7, published by Media Factory

"Asobiniikuyo!" ("Let's Play!")
"I was conscious about showing a cute
image more than for any other book
illustration that I have done. I tried to
express charm and sensuality in the
girls to make them attractive because
the main topic of this story is a romantic
relationship among the main characters."

From a pinup illustration of "Asobiniikuyo!" ("Let's Play!"),
Vol. 7, published by Media Factory

Houden Eizou
放電映像

conscious about them because I draw with my artistic sense, and it is haphazard. I can change colors as much as I want later on, so I'm not worried about the result. However, I feel the accuracy of my vision is improving recently. Yet, when you don't feel good about your line drawings, your vision does not work. For me, it is impossible to make up such a sensation by doing a better job coloring; I have never felt that way.

— It seems there are more people who suffer in coloring, one step after line drawing.

Of course. I have such problems, too. But I can make corrections as much as I want with Photoshop. The flip side is I am not good at coloring. I make changes when I don't know if I should do this step or not. Each time I make a change, I save it and make comparisons later on. While working on the computer, if you draw a picture directly, you can easily make changes in the composition. In that sense, I totally rely on the completeness of my line drawing, so I guess this is my weak part. Actually, there are people who have the ability to decide everything precisely from the beginning, and I think that's wonderful. I'm totally hopeless in that respect since I can't be on either side.

— While drawing, do you have some moments of regret, thinking, Oh, I should have done it this way?"

Oh, that's miserable. Indeed, you can lose your drive. That's why I try to correct everything clearly in line drawings to avoid such misery. While drawing, I have to feel that I'm a genius!

— Some people schedule the time to leave their picture overnight. Once it is done, they later elevate it to perfection, don't they?

Oh well, I do the same. When I'm done with a line drawing, I leave it and sometimes I go take a bath or eat something.

— You do that to change the atmosphere, right? What else do you do for this purpose?

Well...maybe sleep?

— Do you have any hobbies?

I love music and listen to any kind. I also do that to change the atmosphere from drawing. However, I cannot draw a good rough picture while listening to music, so I don't do that so often.

— Is it because you tend to be influenced by the music?

That's right. It's fine when I'm coloring and finishing up line drawings, but when I'm thinking about the compositions, I tend to get more or less influenced by the music I'm listening to.

— On the contrary, doesn't music inspire you to come up with some images? Does that happen?

That is very likely and can happen frequently. I think that either you look at other people's works or listen to music to take in certain information, then you accumulate and convert that information into your own work, and you see the result of your drawing.

Mangas, pictures, and movies are visual. Music isn't, but it is easy to convert it into other forms. I am not biased when I listen to music. I guess that's why I like it so much. I like converting atmosphere or abstract images into concrete forms.

— Then, what would you do if you were asked to choose which you prefer, drawing or music?

I can't choose. Drawing is connected to my livelihood so it's a little different from a hobby. I sometimes start to hate something I don't simply do for a hobby because I feel pressured. I love music because I consider it a hobby, and drawing is something else. If I had encountered music earlier than drawing, I would have been holding a musical instrument. Who knows? Being successful in music is another story though.

— What kind of music do you listen to specifically?

I recently had a chance to get a record player, and I go to record shops to find good records. Record shops are goldmines. The age of progressive rock has arrived.

Book Illustration Works

— In working on book illustrations, a book already has a story, so there are some restrictions in expression, compared to drawing your own original picture. Do you draw the characters first?

That's right. I'm sometimes instructed to draw a picture with a certain image, but I've never been told to create characters with detailed settings. My clients say, "You can do whatever you want," and I rarely receive requests for

From the opening illustration of "Osawa San Ni Dakaretai" ("I Want You to Like Me Osawa") published by Kadokawa Shoten (Sneaker Bunko)

Also, people don't read novels so many times in a week, like ten or a hundred times, unlike a manga. In that sense, first impressions are more important than the images you form after reading frequently.

— **What things do you care about when you actually shape ideas into concrete forms?**
I'm not good at drawing a robot or a machine since I don't have so much experience in those elements. I'm also not good at drawing clothing either, so I know I have to study more.

— **You made your debut with "Asobiniikuyo!" which is a genuine science fiction.**
I was completely amateurish back then, thinking over and over before finally forming my images into a shape. I was desperate.

— **That was your first work, right?**
Yes, it was. When I think back now, I feel I was not good enough to work as a professional. I know I can't do anything but attempt to do my best, so I try to work hard.

— **If you had a job request with specifications that you felt uncomfortable drawing, what would you do?**
Well, they let me work rather freely, so I struggle only when I can't draw as I want. I think I may not have drawn cars. I remember cars didn't look like cars when I tried to draw them. Also, my energy level changes when I draw a girl, rather than a man. I know I should draw both on the same level, but I work really hard on drawing the breasts. I'm not consistent.

corrections of rough drawings of character settings that I submit.

— **So editors don't ask you for corrections so often?**
Well, that's very rare. When I submit my rough drawings, most of the time they say that they look fine. I always prepare myself to be told something, but so far, that's a rare occasion.

— **That's great.**
It's possible the client doesn't have time to ask for redrawing because I submit my works too late....

— **Do you have any points you pay special attention to when creating a setting?**
I can't explain it properly, but I've never had a hard time creating characters. If I read a story well, I think of good images. That doesn't mean my pictures are well drawn, but I think the image you come up with when you first read the story is important. Sometimes I overlook some parts of the setting, so I read again and again or read very carefully, but I try not to forget my first impression of the story. I'm just an ordinary reader, so I also try to think of images that other readers can visualize.

— **What part of the body do you really care about when drawing?**
The hair. Of course, the hair style is important, but I would also like to draw the flow of hair beautifully, to make it appear soft and silky. But if you try to draw more parts more precisely, it takes more time and effort, and you have to care about deadlines, right? It's very difficult to maintain balance. I actually want to draw softer-looking hair in black. I don't like hair that is colored monotonously and looks like a typical animation.

— **Do you love shampoo commercials?**
Of course. I love them.

— **What do you care about when you draw a scene?**
I don't necessarily think that my sense of depiction is really good, but I care about the first impression and I try to draw a picture that readers can easily imagine. Such images, which are pictured in people's minds, depend on the author's ability to express them, and I also depend on the readers' ability to visualize them.

I always try to draw a picture with an interesting composition, but I frequently feel I don't draw well due to my lack of technique. I'll try to improve it from now on, but I know I should draw the best picture I can do for now and not be too confident. It is also important not to misunderstand the settings and descriptions of a story.

— **Do you feel any dilemma about your ability to draw and to create an image?**
Yes, I do. I want to be better at

drawing, and I'd like to be quick in making compositions. If you do this as a job, you have limited time before submission. So, I think I will be able to do more things if I can shorten the work time. In that sense, I'm not at all satisfied with what I am now.

Comfortable Compositions

— **Is impression more important for designing a cover than the description of contents?**
The greatest assumption is to draw a prominent picture for anything. It's nice to see that people pick up my books among others on the store shelf. The important thing is to have people pick up your work. I'd be happy if someone who is interested in my pictures took a look at them for a little while. I put a lot of energy into drawing a cover illustration.

However, I have little knowledge of what's particularly effective for covers, so I just care about where to put the letters and characters, and to place the face of the character in a good position.

— **How do you compare the cover with the illustrations inside the book? Is the cover more difficult to work on because you don't have an original image?**
The cover is more difficult to do when I'm not informed about the contents of the book; I'm worried if the image is good or not. You want to find out the story for a book cover as well. So, honestly, I don't think I can draw anything if I'm told, "Draw an illustration for the cover," without being informed about the content of the story.

— **Any particular points that you care about for compositions?**
I care about feeling comfortable. Then, I consider the positions.

— **"Feeling comfortable?"**
There is a good technical proportion for a compositional layout, right? I draw it with natural intuition, but I feel uncomfortable when characters are positioned in odd places. I don't like oddness. I like a managed dirty room or the trash positioned reasonably, for example. You can even place wrinkles of a shirt in comfortable positions. I don't know a good way to position these elements, but I know my placement is not good, so I try to avoid this awkwardness when I draw a picture. I think positioning of elements depends on your experience as an illustrator.

Now to the Future

— **It has been five years since your debut. Have you had any particular thoughts about your career up to now?**
I still feel, Do I fit in this place? How can I live with this job? Why am I interviewed? Of course. I am directing all my energies to this job, but I haven't been satisfied with my own work so far.

— **As an illustrator, do you have any particular goals?**
My goal is to improve my ability to draw. I am grateful that I can currently dedicate myself fully to my drawing. If you have to do another part-time job, you have a limited amount of time to draw; I feel I get a better response now that I've started to work solely on drawing. So I feel

Houden Eizou
放電映像

"The Fox Spirit of My House"

"Dengeki Bunko gave me a clear description of the
scenes, so I tried to draw illustrations that convey the
relaxing atmosphere of the story to the readers.
I wanted the viewers to visualize the world of this story."

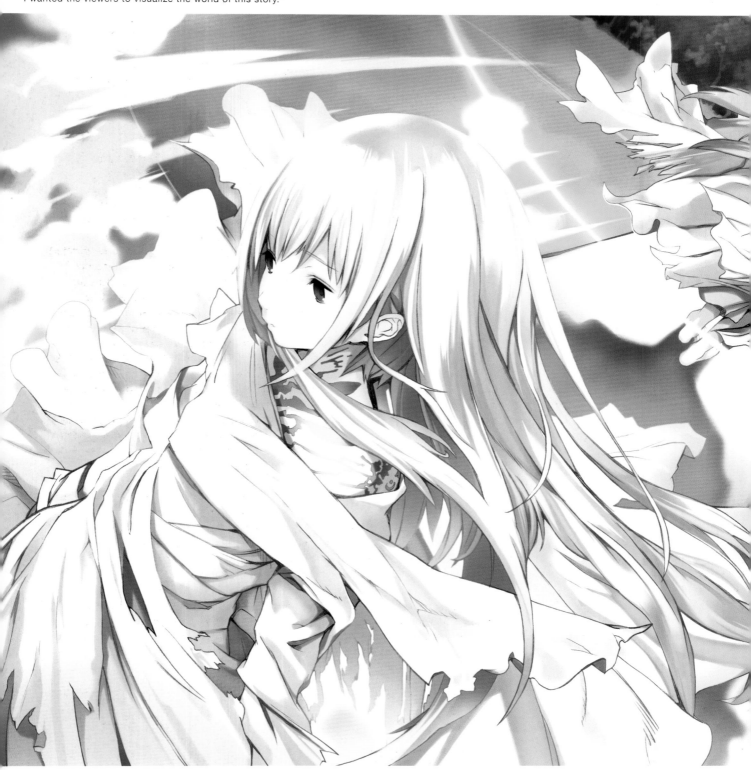

I have improved slightly. I do the best I can.

— It seems that such a stoic mind directs you to good results.
Well, I don't know about that. In my case, I don't have any escape route, so I guess I drive myself to a corner, but I like not having an escape route. If my parents had a family business, I guess I would take that over with no hesitation. Since I didn't have such an escape route, I had to be an illustrator. If you look for success in this field, it might be better to have an escape route, but I can't tell you not to make one just because I don't have one.

I just try to do what I can do. I haven't done anything big, but it feels like I have been walking along the edge of a cliff with my eyes closed. As I look back, I feel the path has been scary. I don't think I could handle it well if I went back to the time before my debut in a time machine, for example. I feel like I humiliate myself when I say that I've been successful.

— What are your future plans?
I'd like to continue drawing manga and possibly hire an assistant.

— Does that mean you want to write your original manga, not book illustrations?
I do have that dream obviously. I want to create something on my

own, whether I can do it or not. I'd like to be involved with movies as well. However, I think I still want to create manga and finish my work in a high-quality way. I know I have to learn more about skills and technologies.

— What would you like to say to amateurs who are trying to be professional illustrators?
Well, it's been only a few years since I made my debut as an illustrator, so I don't have much to say, but I guess you shouldn't be satisfied with what you are at this moment. I feel that the level of my drawing quality at the time I started this career was too low for a professional. In that respect, I feel lucky to have succeeded at an early stage, but I don't think I should be satisfied just because of my early success. You shouldn't close yourself and be withdrawn, thinking that you'll never be satisfied; you should be positive to show yourself to others. It doesn't pay to be too proud of yourself and be satisfied with what you have.

You also have to input a lot of things in your life. Earlier, I mentioned that I listen to music while drawing, but I also look at many other drawings, mangas, or watch movies. I think you should determine your favorite fields in life. You could actually list them. It would be good for you to draw many pictures after doing that. I believe that output does not exceed input.

From the opening illustration of "The Fox Spirit of My House (4)," Dengeki Bunko

Houden Eizou
放電映像

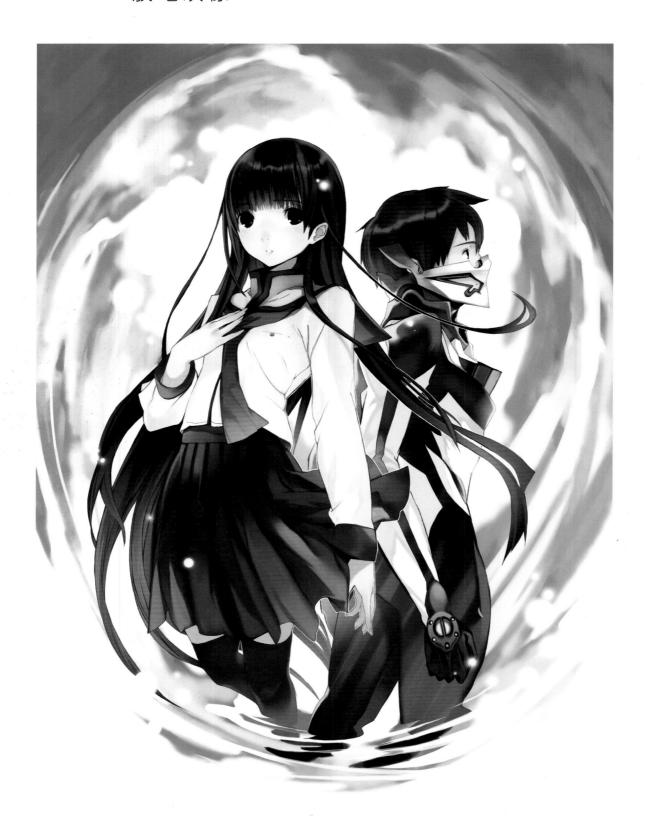

"Osawa San Ni Dakaretai" ("I Want You to Like Me, Osawa")
"I wanted to draw Osawa's black hair with a fine touch, but it was difficult to use black. If I made the hair too black, it would lose its solid texture, and if I added colors in a funny way, it would lose the good feature of the black hair. I thought that blue might be the appropriate main color because of the water monster that appears at the end of the story."

From the cover of "Osawa San Ni Dakaretai" ("I Want You to Like Me Osawa") published by Kadokawa Shoten (Sneaker Bunko)

Houden Eizou's Publications

Houden Eizou designs cover illustrations for various novels. Here are some of his latest works.

"The Fox Spirit of My House (5)"
By Jin Shibamura

This is a story of the daily life of the revived spirit of the fox Kugen and the Takajo family. It is a popular drama series with a romantic setting.

• Published by MediaWorks, Dengeki Bunko

"Asobiniikuyo!" (Vol. 7)
("Let's Play!")
By Okina Kanno

Kio, a high school student who lives in Okinawa, meets the girl Elise on the occasion of the Buddhist service. She has cat's ears and a tail, and claims to be an alien. This popular story excites readers from one volume to another.

• Published by Media Factory, MF Bunko J

"BloodOpera-Entice Us, Red Holy Communion"

This publication from Elseware is a game story that is played by means of sending mails. The story centers on the black vampires "Dreegga" and red humans "Roadh." The official Web site contains easy-to-understand instructions for beginners.

• Project managed by ELSEWARE Ltd.
• Official website: http://bloodopera.jp/

"Osawa San Ni Dakaretai"
By Yoshikazu Kuwashima

Mamoru Daichi becomes a hero of justice. He became popular, unlike Osawa who used to be a good female friend of his. This great piece of work consists of slapsticks and seriousness at the same time, with crucial scenarios from heroic stories. It also shares emotions of pain and sorrow.

• Published by Kadokawa Shoten (Sneaker Bunko)

2

Gallery:

Hot New Talent

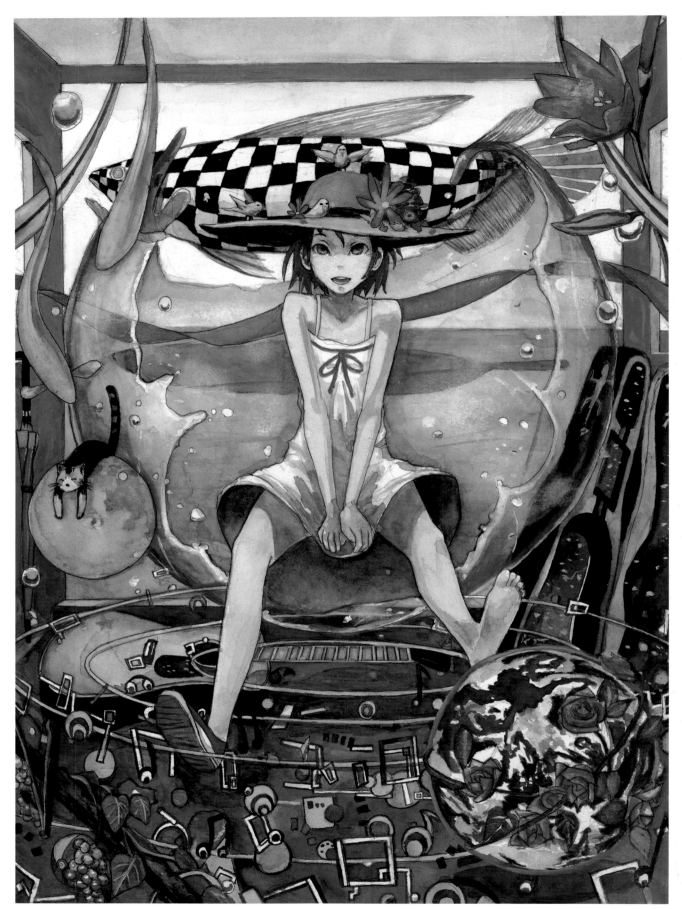

"Calm World"

Yukihiro Nakamura, age 22, Nara Prefecture
Transparent watercolor/acrylic paint/Cotman watercolor paper

"I drew this picture as the image of a world without conflict. A grapevine twines around the rusted sword, which utters the language of a flower known as charity, and the language of a rose known as love. These are always in bloom all around the earth."

"Let's Dance"
Maro, Hokkaido
Liquitex/acrylic paint/watercolor
"I'd like to be skilled enough to be able to express the tender flow of time."

"Cage"
Yuta, age 21, Miyagi Prefecture
Transparent watercolor/acrylic gouache
"Can we use photocopy paper?"

"Kikuka Girls"
Shinobu, Osaka City
Acrylic/modeling paste

"I think that nursery rhymes and the special charm of boys and girls have something in common."

"Goldfish in Dream Colors"
Kana Otsuki, age 21, Kyoto City
Acrylic gouache

"I wanted to draw a girl with a heartwarming aura (right girl). I also enjoyed drawing the background with a pattern that resembles plankton. I wanted to create a peaceful atmosphere, but I felt I might have drawn too much."

"Memory of the Wind"
noa, Tokyo
Transparent watercolor/pen

"The picture seems to lack coherence."

"Etoile"

Rakisic, Fukuoka Prefecture
Transparent watercolor
http://www4.plala.or.jp/arorao/

"I drew this picture with an image of sweets in mind."

"Do You Remember?"

Gen, age 21, Chiba Prefecture
Crayon/watercolor

"I was so nervous when I worked on the scraped parts because I could do it only once."

"Autumn Performers"
Nekobayashi, age 23, Nagano Prefecture
Transparent watercolor/colored ink

"This work shows a group of street performers. Two of them belong to 'Autumn Wind Brigade.' I have yet to master the use of various paint media."

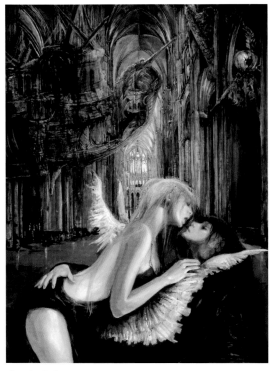

"Prelude"
Ame Ichinose, age 19, Ehime Prefecture
Acrylic gouache/gel medium

"I tried to be aware that every single element in this painting has to be heard. I will be glad if everyone can hear the voices echoing inside the huge church."

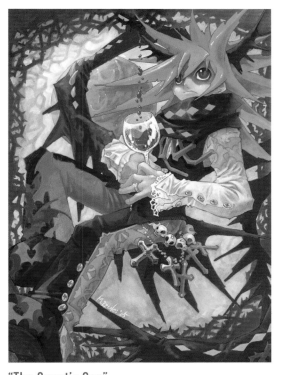

"The Count's Son"
Mizuki, age 21, Shizuoka Prefecture
Acrylic gouache/gesso/colored pencils

"I imagined a vampire during Halloween, but it took longer for me to draw it than I expected."

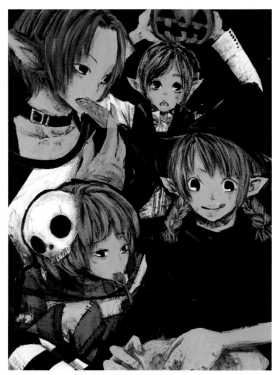

**"Eve of a Halloween Party/
Making a Jack-o'-Lantern"**
Aya Adachi, age 19, Niigata Prefecture
Liquitex

"It was difficult to draw the fine lines with Liquitex. I tried my best to finish it like an oil painting using thick coating. I wanted to add more shadows on the characters' faces to create a completely dark atmosphere."

"Dumb Show"

Chinami Kobayashi, age 20, Kyoto
Copic multiliners/cartridge writing pen/whiteout

"I originally wanted to draw a woman who watches a festival through a window of the Japanese-style room, but I ended up drawing a woman who is looking at a man."

"Tayutauta"

Sae Ishikawa, age 24, Okayama Prefecture
Photoshop/Dr. Ph. Martin

"The girl's hairstyle is modeled on Satan's horn."

"Time to Dream"

Hamikko, age 24, Fukui Prefecture
Gansai colors

"Lichter—People Who Hold the Light"

Ushio Sena, age 21, Kanagawa Prefecture
Acrylic gouache/colored pencils

"The building in the background is an imitation of Brueghel's Tower of Babel. I borrowed it as a representation of humanity's desire for authority, title, and public standards. It symbolizes a strong power to constrain oneself. Man shall jump over hurdles and live with all his might for the future."

"Festival"

JEAN, Aichi Prefecture
Black pen/Photoshop/Illustrator/kimono fabric

"Play! Dance! Fight! Eat! I want to do all of these things all at once."

"Long Dream"

Masako, Yamaguchi Prefecture
Acrylic gouache/Liquitex

"It was fun to make the clothes look antiquated."

"Queer"

Rie Toi, age 21, Shiga Prefecture
Transparent watercolor
http://smile.poosan.net/glad/index.html

"I am challenged by various types of pictures. The volume of my favorite pictures seems to expand, and it is a fun process for me to select from them. I simply aim for 100% entertainment."

"Purple Flames That Call the Incubus"

Reiya Kisaragi, Ibaraki Prefecture
Flash MX
http://poison.itigo.jp/rain/

"I grab the picture that only I can draw."

"It Shines When You Sing"

Ari Tomobe, Hokkaido
Poster color/colored pencils
http://sunchoco.dw.land.to/

"The title speaks for itself. When you sing a song, the day shines."

"Untitled"

Hamlet Okinawa, Tokyo
Acrylic paint
http://sagyou.fc2web.com/

"The girl in the lower right part of this painting is my favorite character."

"Prelude"

Oropi, age 24, Tokyo
Photoshop

"There is a beginning within an ending. One cannot give up hope in the middle of despair—I drew such an image in this painting."

"Fallen from Heaven"

Retro Hinosaki, age 21, Hokkaido
Copic/watercolor/acrylic

"It was my first time drawing a picture that involves a man and a woman, and I tried to make it a subtle image. I had a hard time drawing these two characters because of their naked upper bodies."

"6:00 a.m., Scrap Place"

Reiji Shinya, Niigata Prefectre
Acrylic gouache

"I like to paint the skin color of people's faces. I studied color coordination, so I paid attention to the balance of colors, yet, I only came up with neutral ones. Perhaps I am not at all gifted with using colors."

"Celebration of Urban Life 01"

Lok Jansen, age 33, Tokyo
Sakura SIGMAGRAPHIC/Photoshop CS

"'Celebration of Urban Life' refers to the beauty of a city and the attempt to rediscover it as a place where we live our daily life without much thought. I drew the illustration by hand, using the motifs of an actual city, then finished it up with Photoshop."

"Peony Flowers and Their Relatives"

Gen Shibata, age 28, Akita Prefecture
Photoshop/Illustrator

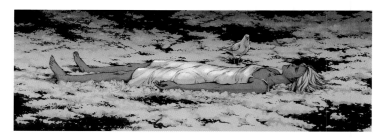

"About Seagulls/Concept"

foo*, age 21, Saitama Prefecture
Photoshop/pen/cartridge writing pen
http://www.geocities.jp/foomidori/

"The image in this painting is like the rehearsal of a graduation project. 'About Seagulls' is the theme on which I have been drawing for four years."

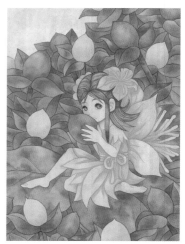

"Will I Also Become Red Soon?"

Mushimaru, age 21, Miyagi Prefecture
Watercolor

"It took a lot of time for me to paint this picture even if it is merely a simple illustration."

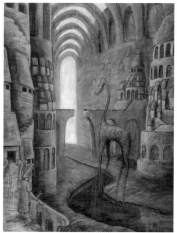

"Town Where a Red Animal Lives"

Hogwy, Shiga Prefecture
Acrylic

"I like the vast and tranquil atmosphere in a great landscape where gigantic buildings stand in a row. I wanted to draw the light coming inside a dim architectural setting, but that was difficult to show."

"Hundred Demons Night Parade: Sea"

Madoka En, age 29, Tokyo
Transparent watercolor/acrylic gouache/ Misnon whiteout

"I painted this picture by hand for the first time in months. I thought that the warmth of my hands was important in painting. I hope that my drawing can transmit the good feeling of sailing at night."

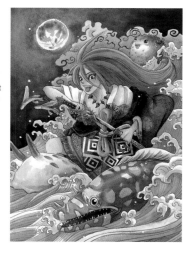

"Image"

Kayo, Nagano Prefecture
Copic/pencils/paint

"I tried to express a refreshing touch, like the inside of my head when I am trying to think what I am going to draw."

"Hide-and-seek"
Curimu, Fukuoka Prefecture
Paint/colored pencils

"I used paint for the first time in several years."

"Camp"
Mutsumi Takashima, Hiroshima Prefecture
Watercolor

"Human Being"
Masanori Kishizuka, age 23, Hyogo Prefecture
Pen/ink/markers

"I drew this picture based on my friend's poetry."

"Dreamer"
Naki, age 23, Kyoto Prefecture
Watercolor/acrylic/Photoshop

"Unknown Space"
Masato Murata, age 23, Kanagawa Prefecture
Copic

"I tried not to make a single mistake to finish the work perfectly."

"Rain That Falls on Us"
Asako Hino, Tokyo
The Graphics

"In using computer graphics, I found it difficult to get the right colors that I imagined at the time I printed it out."

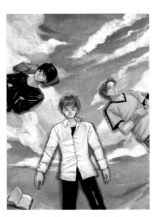

"Something Visible"
Yumi Nishi, Kyoto Prefecture
Transparent watercolor/colored ink/acrylic

"The three characters see the same dream."

"Dash in Adolescence"
BASHI, Miyagi Prefecture
Photoshop

"I was influenced by an animation movie that I saw for the first time in many years."

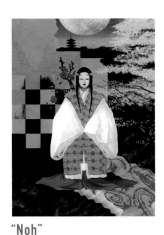

"Noh"
MI, age 20, Tochigi Prefectire
Acrylic gouache

"I went to Kyoto several months ago, and I was enchanted by the overwhelming buildings."

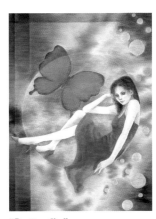

"Butterfly"
Kira Sunahara, Hokkaido
Watercolor pencils/turpentine
http://saisyoku.daa.jp/

"I imagined an evil woman who flutters around like a butterfly."

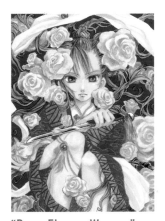

"Rose Flower Woman"
Minami, age 21, Kanagawa Prefecture
Opaque watercolor/colored ink/acrylic color

"I tried to draw a combined atmosphere of Chinese and Western styles. I was nervous because the rose looked like a peony."

"Going Back to Somewhere"
Kanahebi, Chiba Prefecture
Colored pencils/Copic/pastels

"I struggled very much while drawing this painting."

"Autumn Night of a Witch and Mushrooms"

Yurie Takizawa, age 19, Niigata Prefecture
Liquitex

"When the sun sets and the mushrooms are about to go to bed, the witch, whose favorite food is mushroom soup, casts a spell on the mushrooms, which then enter the house. The mushrooms jump into a large pot of boiling water. Soon, the soup is ready to eat. In this picture, the witch chuckles while looking at the soup."

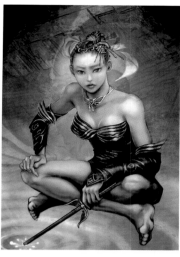

"Moment of Regeneration"

Megumi, Tokyo
Photoshop
http://home.catv.ne.jp/ff/clair/

"The theme is a requiem for destroyed nature and a prayer for its recovery. The destruction of the environment has accelerated without pause, yet, what can each of us do? Shouldn't we try to do something about it? I conceived this theme from the importance of a single drop of water. The character exists as the 'Maiden of Gaia,' and the background image is the water planet, Earth, which is under the process of regeneration."

"Before the 8th Day and Morning of the 7th Day"

Owamaru, Tokyo
Acrylic gouache/pencils

"Using the cardboard and pencils has helped me, although I am not good at using gouache."

"To You in Silence"

Seiko Ogisho, Kanagawa Prefecture
Kent paper/colored pencils

"I drew this picture with an image of the soft morning light."

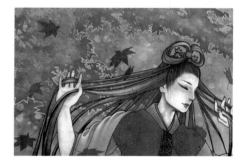

"Princess Tatsuta"

Hippe, age 24, Gifu Prefecture
Acrylic/colored ink
http://harmonia-mundi.chu.jp/

"I tried not to be reckless in taking up the challenge of working on this painting. I created a picture that integrated painting methods I have used until now to achieve successful results. My subject is the goddess of autumn, Princess Tatsuta."

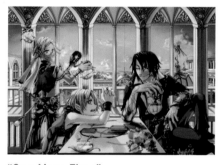

"One More Time"

Erii Mano, Aichi
Painter

"I often have dreams of a hot desert, maybe due to the recent heat."

"Crimson"

Koji Fukuchi, Osaka City
Colored ink

"Quiet Life"

Setsu Nisso, age 20, Osaka City
Mechanical pencil/Paint Shop Pro

"I drew this picture while listening to Bonnie Pink's 'Quiet Life.'"

"A Gentle Song Dedicated to Pico"

Tatukikawa Ituki, Okinawa Prefecture
Transparent watercolor/Indian ink

"Pico is surrounded by warm affection every day."

"World of Autumnal Colors"

Atusi, age 36, Kanagawa Prefecture
Transparent watercolor/Copic

"I wanted to draw the evening glow."

"Drifting and Dozing"

Yama, age 19, Hiroshima Prefecture
Acrylic gouache/colored pencils

"This is an image that I had wanted to draw for a long time. I dream of sleeping in water."

"Where You Turn, You Find the Person You Were Waiting For"

Etsuko, Aichi Prefecture
Photoshop

"I used bright and clear colors, and wanted to draw an apparently static but dynamic picture."

"Moon, Girl, and..."

Erika Koyama, age 19, Niigata Prefecture
Watercolor/acrylic gouache/colored pencils

"I drew this picture in the setting of a girl falling in love with a man. In order to express fully the painful feeling and uneasiness of loving someone, I used calm colors such as black, sky blue, and others. I also tried to add a lonely atmosphere in the expressions. By using colorful colors in the girl's hair and the flower, I showed that the girl is becoming increasingly beautiful after she falls in love."

"Stroll Along the Ocean"

Amanicha 10, Kanagawa Prefecture

"I drew what I wanted to try to express."

"Us"

Tomomi, Kyoto City
Fisheye Photoshop

"I used a camera with a fish-eye lens called Fisheye, and combined the pictures of my cats and my portrait paintings. I like using cameras and take many photographs every day."

"Performance"

Yomosugara, age 17, Hokkaido
Colored pencils/Copic/Photoshop

"I drew this picture in association with music."

"Playing Under the Moonlit Night"

Raito, age 21, Yamaguchi Prefecture
Transparent watercolor/poster color/colored ink/Kent paper

"I had a hard time drawing this picture, perhaps because I am still unskilled, but I will devote myself to further improve my painting ability."

"Tone of Old Books"

Yuzuki, age 20, Tokyo
Colored ink/Copic/colored pencils

"I wanted to express the shabby atmosphere that drifts out of the first page of a book and the sound that flows out of it."

"Saviour"

Eri Nakagawa, age 19, Niigata Prefecture
Liquitex/Watson paper

"The main character of this original story is Nike."

"Agony of Pain in Growing"
Yumi Inasaki, age 17, Saitama Prefecture
Acrylic gouache
http://denyen.x0.com/

"The painting was hard to do because the acrylic paint dried out so quickly."

"Lamp"
Mizuki Matsukawa, Niigata Prefecture
Copic/colored pencils/pastel

"I think the colors have become old-fashioned, dark, and warm, but I am satisfied that I made the best use of the paper quality."

"I Will Become a Flower Someday"
Itachi, age 20, Osaka City
Watercolor/Photoshop/Copic

"I mainly used red and green colors with Japanese flowers."

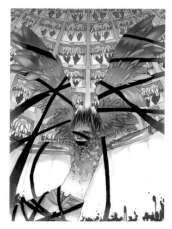

"This Is One of Them"
Mizore, age 19, Aichi Prefecture
Copic

"It is difficult to find out what suits one best out of a great number of things. There is always a trap in grabbing a beautiful thing."

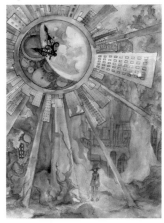

"Equinox Week Starts on the Day of Memorial Service"
Nakaman, Shiga Prefecture
Acrylic gouache/colored Indian ink/pencils
http://homepage3.nifty.com/kimitan1982/

"The first image I wanted to impart was a melancholic departure, titled 'Morning of the Door to the West.' which coincided with the theme of 'I have to let go, although it is sad.' Hence, the title of this painting was taken from this line of thought, which also reflects my current circumstance."

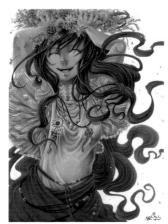

"Marina"
Kai Otowa, age 17, Kanagawa Prefecture
Acrylic gouache/Liquitex/colored pencils

"I did not use any tricks in this painting, but I felt happy while I worked on it. I think that's an important thing. I also placed dried flowers over the head of the character."

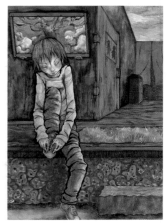

"Time That Doesn't Stop"
Aruf, age 18, Tokyo
Transparent watercolor/watercolor pencils
http://www.geocities.jp/kaityuudokei_aruf/

"I love clocks and cities. I like drawing people, but I thought it was also fun to draw pictures where people were not the major motif."

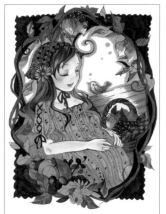

"Song of Fruits"
Natsuna Niikura, age 20, Saitama Prefecture
Copic

"The autumn fruits and the expression of the main character, who is an expectant mother, are the central focus of this picture. Do you see her singing a song to the baby in her belly? I still have so many things to learn, such as the use of Copic, drawing of details, and more, and will do my best to master them."

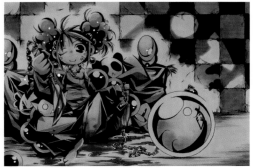

"How About Freedom With Blood?"
Atsuto Tsukishiro, age 24, Kyoto City
Pens/colored ink

"I often thought that people around me do not have a good impression of my pictures. They make fun of me and criticize me; they look down on me, yet I seriously feel that life is not just fun as I walk toward my dream. I drew this picture with the determination and enthusiasm to continue that dream."

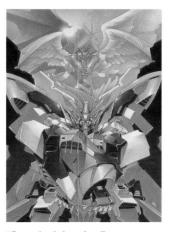

"Waking Up from the Midnight Dream"

Sakae Kashiwao, age 21, Kanagawa Prefecture
Copic/pastels/pencils/drawing pen

"I wanted to draw a strange and unstable feeling of the moment when you are not sure if you are in a dreamworld or in reality—like when you just wake up from a dream. There were many things that I wanted to emote, so the picture may have been crammed with too many elements."

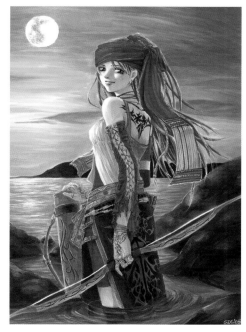

"Smile"

GDL, age 18, Tokyo
Copic

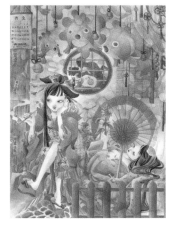

"Proof of Justice"

RYO, age 29, Saitama Prefecture
Acrylic gouache

"You can hear the loud voice saying, 'Zeon-Zein! Fire! Mode!'"

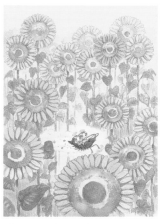

"Maiden in Red-light District"

Takato Shinozaki, Hokkaido
Acrylic gouache/Alcohol markers
http://shino.chips.jp/

"What does a 'sold' girl see?"

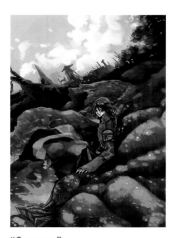

"Prawn Motorbike"

Kei Minamine, Shiga Prefecture
Acrylic Gouache/transparent watercolor

"I hope you can hear the sound of the prawn motorbike."

"Gemma"

kom, age 22, Aichi Prefecture
Painter
http://homepage3.nifty.com/woozy/

"I wanted to draw a world surrounded by a blue tone."

"Tropical Girl"

Kinoppie, age 17, Tokyo
Open Canvas

"I drew this picture with an image of a pretty girl in a southern country."

"It Surely Exists"

Yui Kaoru, age 24, Hokkaido
Colored pencils
http://yuikaoru.fc2web.com/

"I left my idea for this work in my head for so long that the character has grown up."

3
Story Manga

This chapter presents two manga stories with accompanying illustrations exclusively created for *Comickers Art*.

Spider House

A boy is constantly annoyed by a big spider web inside his house. He tries to destroy the web but fails, and asks his mother for help. One night, his mother told him "I love you," and he was awakened by something. This visual short story was written by Yumi Moriyama and Rin Fujiki who have drawn a mysterious world of beautiful illustrations and strange scenes that are not seen in daily life.

ぼくの部屋の隅に、蜘蛛が巣をはっている。

巣の主は結構な大蜘蛛で、
ひどく不吉な感じがする。
ぼくは奴の巣を取り除いたが、
何度やっても、また元通りの巣ができていた。

「いいや。別に悪いことをする訳じゃないし」
――それは大きな間違いだった。

蜘蛛は、我がもの顔で、
ぼくの部屋を歩きだした。
ぼくの身体の上を平気で這い回ったりもする。

怖くなったぼくは、お母さんに相談した。
「お父さんが帰ってきたら、退治してもらいましょうね」
お母さんはそう微笑んだが、お父さんはあまり家に帰って来ない。
「お父さんが帰るまで、お母さんの側を離れないで」

その日からぼくは学校に行くのをやめた。
お母さんと一緒にお父さんの帰りを待つことにした。

蜘蛛の家

invisible Stories

Rin Fujiki/yoShimi moriYama

invisible stories 3

森山 由海×藤木 稟

　そのときだ。

　突然、バタンとドアが開く音がして、ふっと身体が軽くなった。

「ぎゃ」という短い悲鳴が後に続いた。

　お父さんの足元には、裸のお母さんが倒れていた。

　おそるおそる目を開くと、お父さんが鬼の顔で立っている。

　だらり……。

　お父さんが手にした包丁から緋色の糸が伸び、お母さんの膨らんだお腹の上に垂れ落ちたとき、ぼくの記憶も、ぷつりと切れた。

ぼくは夜が嫌いだ。夜になると、また、奴がやってくる。

ぼくをねばねばした糸でしばり、身体の上をガサゴソとまさぐっ

息苦しくて、たまらない気分だ。

けど、きっとこれは悪い夢なのだろう。

だって、朝になり、目を覚ますと、ぼくを縛っていたはずの糸はないのだ

すると。

そこにいたのは、大きな大きな化け蜘蛛だった。

お尻を上下に振り、そこからしゅーしゅー糸をこぼしている。

長い脚でぼくを羽交い絞めにし、ガサゴソ身体をまさぐり、黒と黄色の大きな腹

をぼくの身体に押し当てている。

ぼくは思わず悲鳴をあげた。

ぬっと、化け蜘蛛の顔がぼくを覗き込んだ。

……とてつもなく、気分が悪い……。息が苦しい……。

「大丈夫よ……。安心なさい……。愛しているわ……」

ある夜、お母さんの声が聞こえ、ぼくは、うつろな目を開いた。

目覚めると、ぼくは、おじいちゃんとおばあちゃんの家にいた。
ぼくはどうすればいいのかと訊くと、
「ここでお母さんの帰りを待とうね」とおばあちゃんは答えた。

お母さんはなかなか帰ってこなかった。
かわりに、見知らぬ赤ん坊がやってきた。
あやすとよく笑ったけれども、そのたび、
ぼくの頭は不安な気持ちでいっぱいになる。

赤ん坊を見ていると、頭の後ろの方から、
ガサゴソと、奴の不吉な足音が聞こえてくる。

そんな気がしてたまらない。

森山 由海（もりやま よしみ）

装幀家、挿絵画家。
1995年、装幀挿絵画家・藤原ヨウコウとしてデビュー、2004年夏に改名。
ファウスト（講談社）で、清涼院流水氏とのコラボレーション企画「イラストリック・シャッフル」

藤木稟（ふじき りん）

小説家。
代表作に、"探偵・朱雀シリーズ"（徳間書店）、"陰陽師鬼一法眼シリーズ"（光文社）など多数。
『SUZAKU』（作画・坂本 一水、幻冬舎コミックス）『ヴァーチャル・ビースト』（作画・星野和歌子、角川書店）
など、マンガの原作でも活躍中。

Space Oiran

This enchanting story begins with the
appearance of a a mysteriously beautiful woman
surrounded by restless people who feel anxiety
and fear. A procession of courtesans leads
towards the palace of the leopard's head. Upon
arriving at the palace one of the courtesans lifts
up a baby. This elaborate work was drawn by
Hiroki Mafuyu.

Space Oiran

√ 1 *a perfect circle*

ュ[K.q.3004]xシ-V ノェ[Yュン

遙彼方_
飛翔螺旋的時空間 _トvト?トWトFト女人們來

携奉献品_ト[トeトBトXトgユB 特別複製嬰児ZQ㐂B
D.N.A__Special Design Baby_

此星レ孤獨的大王_[トeトBトXトgユB 為求了_ 後嗣…

穿過完美的光的輪 −Sェ名妓_ 遮住不安和恐怖「1レ2レB
__偽「花魁道中」始

ひろき真冬

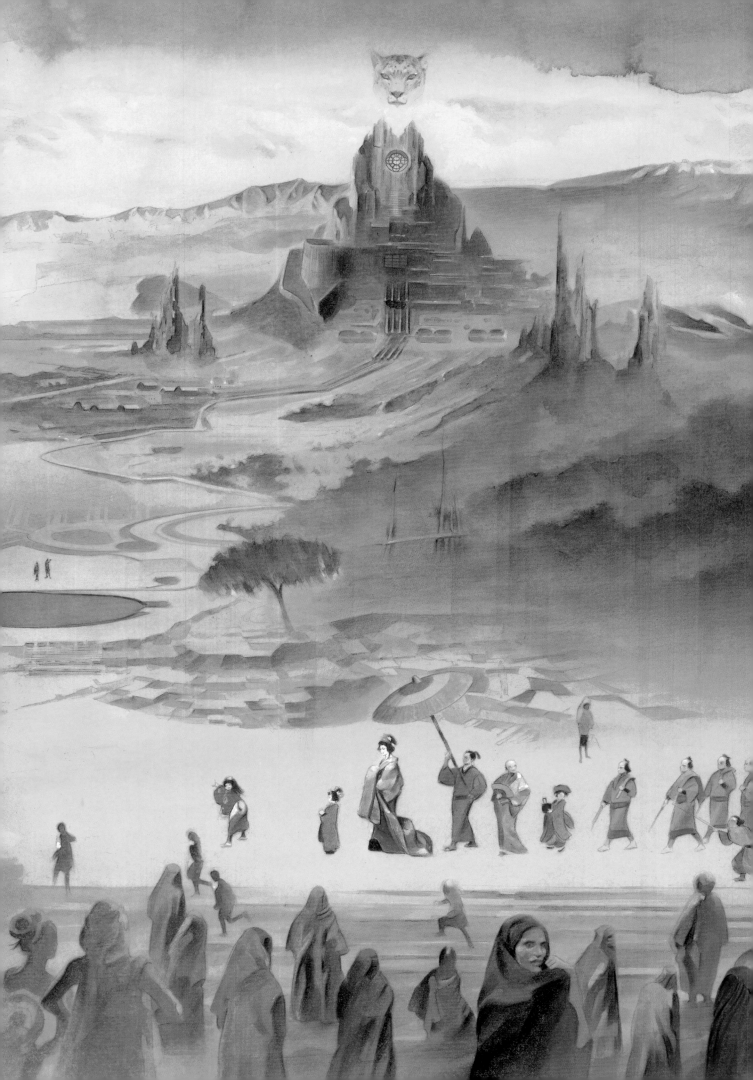

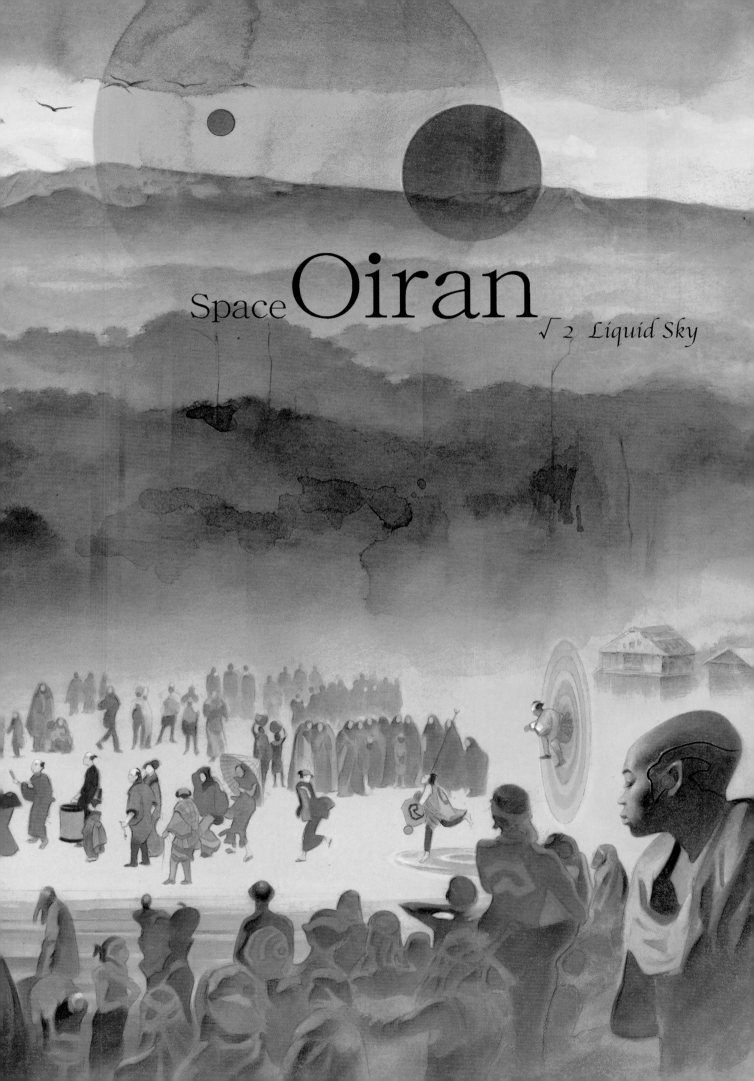

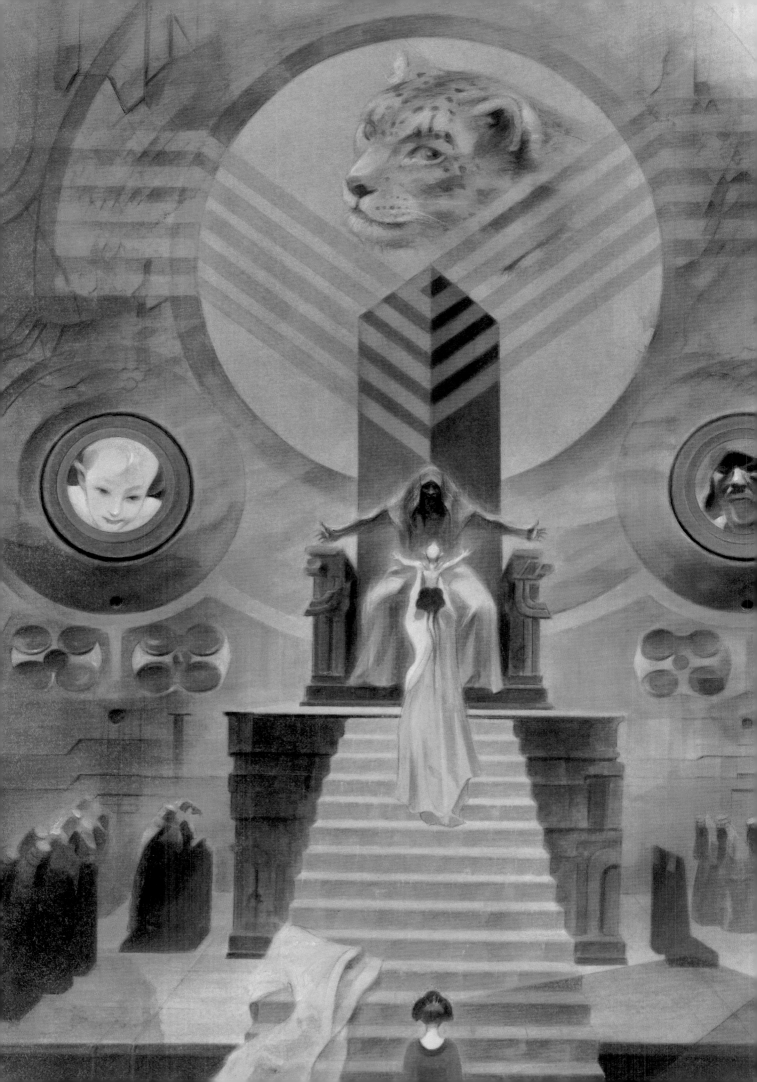

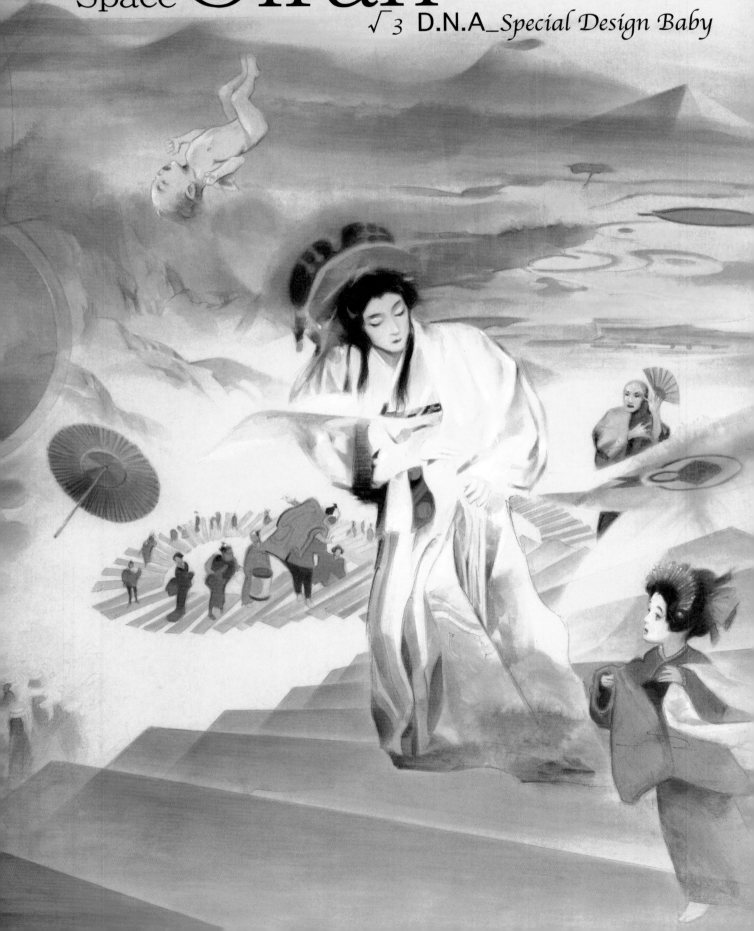

Space Oiran

√3 D.N.A_Special Design Baby

Space Oiran

√ 4 All Tomorrows Parties

4

Gallery:

Master
Artists

Tsubasa Takanashi

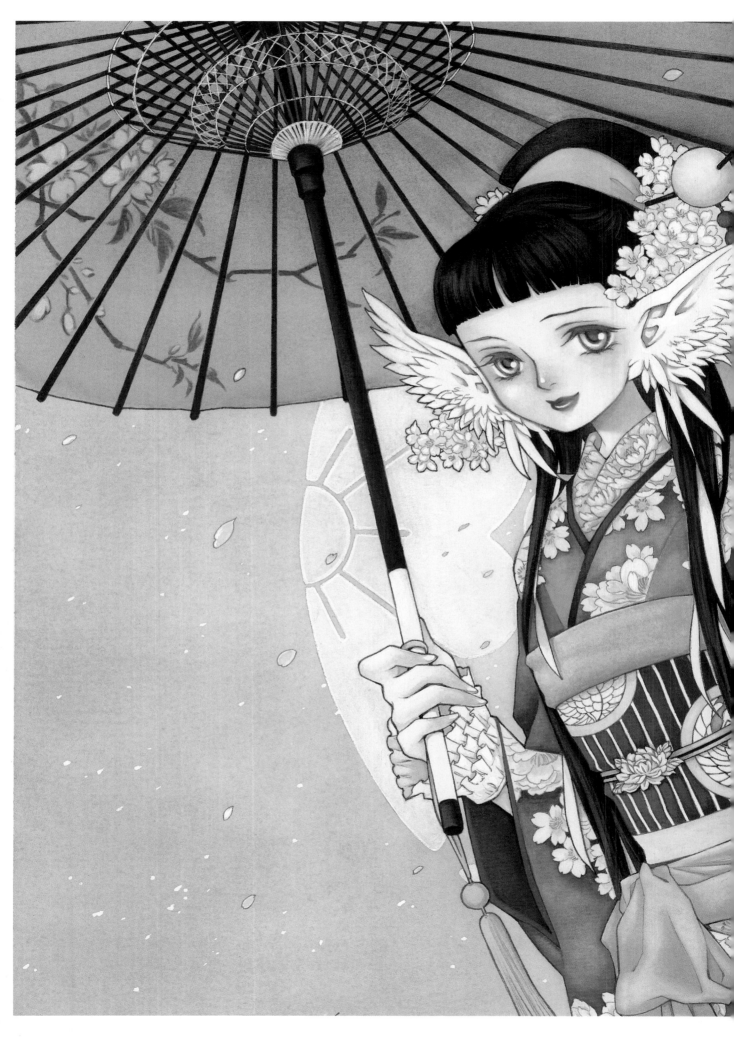

Kohime Ohse

Chen Shu-Fen + PIN-FAN

Chen Shu-Fen + PIN-FAN

Tatsuyuki Tanaka

Lily Hoshino

noa

Yoshitoshi Abe

Waka Miyama

Index

DATE DUE

MAY 3 1 2013		
SEP 1 6 2013		
JAN 3 1 2014		
JUN 1 9 2015 LION		
NOV 2 8 2016		
DEC 0 6 2017		
JUN 2 9 2018		
	DISCARD	

Demco, Inc. 38-293